LATENT IMAGE

LATENT IMAGE

The Discovery of Photography

Beaumont Newhall

University of New Mexico Press • Albuquerque

Library of Congress Cataloging in Publication Data
Newhall, Beaumont, 1908–
 Latent image.

 Previously published as: 1st ed. Garden City, N.Y.:
Doubleday, 1967.
 Bibliography: p.
 Includes index.
 1. Photography—History. I. Title. TR15.N475 1983
770′.9 83-10494
ISBN 0-8263-0673-X

CONTENTS

vi

PREFACE

This book was originally published in 1967 by Doubleday & Company for Educational Services Incorporated as one of its Science Study Series. These small paperback books were written on various aspects of science and technology with the intention of interesting young students in adopting science as a career. This narrative of how photography came about is also a case history of the simultaneity of invention by independent thinkers. Although an elementary knowledge of chemistry and physics was assumed, the book met with the favor of general readers and has appeared in Italian, German, and Japanese editions.

I am particularly indebted to three eminent photographic scientists for helping me to understand the scientific theory of the photographic process: the late C. E. Kenneth Mees, Cyril J. Staud, and Arnold Weissberger, formerly of the Eastman Kodak Research Laboratories, Rochester, N.Y.

I thank the University of New Mexico Press for bringing this long out-of-print book back into circulation. The original format has been preserved and the text is unchanged except for minor corrections.

Beaumont Newhall

Santa Fe, N.M.

INTRODUCTION

Photography has no single inventor. At the same time, distantly removed from one another, experimenters were working on the same problem unaware of each other's work until, in January of 1839, an announcement was made in Paris by the Académie des Sciences of the success of one of them, Louis Jacques Mandé Daguerre. What had been underground now came to the surface as other experimenters challenged Daguerre and claimed priority. The mutual reaction between these pioneers, each learning from one another, each striving to outdo the other, produced at last a universal technique. How this came about is the subject of this book.

Elsewhere* I have written the history of picture-making by photography. In this book the discovery of photography is described from a scientific and technological standpoint. We shall follow the laborious experiments of the pioneers with today's knowledge of how photography works.

Almost every substance is altered by light, some to a greater extent than others. On this phenomenon photography depends. If light-sensitive material is exposed to an image, the varying intensities of light form-

*The History of Photography from 1839 to the Present Day, revised and enlarged edition (New York: The Museum of Modern Art, 1982. Distributed by New York Graphic Society Books).

ing the image can be recorded and made visible. If the unexposed sensitive material is desensitized or removed, the record becomes permanent.

Many light-sensitive substances have been used in photography, but the most common are the halides of silver—the chlorides, bromides, and iodides. The pioneers worked out non-silver processes, but since the silver processes were the first to become practical, they are described here in more detail. It is notable, however, that all the processes envisioned by the pioneers sooner or later became practical.

Silver halides become dark on exposure to light because they are reduced to finely divided particles of metallic silver and halogens. The reaction takes place not only on exposure to light, but also to rays that lie beyond the visible in the electromagnetic spectrum. Properly, therefore, we should speak of the sensitivity of silver halides to radiation.

So long as photography depended on the direct reduction by radiation of the silver halides to silver, known in the language of photography as the "print out" process, exposures were too long for the technique to be practical. It was soon discovered that very much shorter exposures produced certain changes in the silver halides which, though invisible, enabled them to be reduced to silver by chemical aftertreatment. This fundamental system is a phenomenon comparable to the amplification of weak, inaudible radio signals to sound. The extent of the amplification is very high: if only a few atoms of silver are reduced by light, tens of millions more can be reduced by development. With this discovery of the development of the latent image, modern photography was born.

CHAPTER I

DAGUERRE'S SECRET

On January 6, 1839, the Paris newspaper *Gazette de France* announced "an important discovery made by M. Daguerre, the celebrated painter of the Diorama. This discovery seems like a prodigy. It disconcerts all the theories of science in light and optics, and, if borne out, promises to make a revolution in the arts of design.

"M. Daguerre has discovered a method to fix the images which are represented at the back of a camera obscura; so that these images are not the temporary reflection of objects, but their fixed and durable impress, which may be removed from the presence of those objects like a picture or an engraving.

"Let our readers fancy the fidelity of the image of nature figured by the camera obscura, and add to it an action of the solar rays which fixes this image, with all its gradations of lights, shadows, and middle tints, and they will have an idea of the beautiful designs, with a sight of which M. Daguerre has gratified our curiosity. . . .

"Inanimate nature, architecture, are the triumphs of the apparatus which M. Daguerre means to call after his own name—*Daguerotype* [sic]."

Thus the world first learned of the process which was soon to be called photography. The announcement stated that Daguerre worked with polished metal plates and that in three minutes he could produce views of Paris boulevards and the river Seine "given with a truth which nature alone can give to her works." The *Gazette de France* reported that the invention was of such potential importance that it was to be investigated by three members of the Académie des Sciences: the astronomer François Arago, the physicist Jean Baptiste Biot, and the naturalist Alexander von Humboldt.

The Diorama

Louis Jacques Mandé Daguerre founded in 1822 (with Charles-Marie Bouton) the Diorama, a theater without actors, where extraordinary illusions were created with remarkable lighting effects and huge pictures shown on three separate stages. The audience paid 2 or 3 francs admission to be transported as if by magic to a Swiss valley, Canterbury Cathedral, the tomb of Napoleon at Saint Helena, and other famous monuments and sights. The lighting effects made the pictures, which measured $45\frac{1}{2}$ by $71\frac{1}{2}$ feet, change as one looked at them. The viewer could hardly believe that he was looking at painted canvas and not nature; the illusionism of the paintings became even more astounding when coins thrown into what seemed to be deep space rebounded from the canvas and fell to the

stage floor. In some of the later Dioramas the effect was of one image dissolving into another: an Alpine village was swept away by an avalanche; darkness filled a church, candles were lighted, the faithful came to Midnight Mass, then the dawn sun lighted the stained glass windows. Two shows were given consecutively. The auditorium floor was circular, and was revolved between shows; but it seemed as if the theater walls themselves were moving as the viewer's line of sight shifted from one proscenium to the other.

The extraordinary illusions depended upon the most exact perspective in the paintings, and both Daguerre and his partner Bouton used cameras to guide their drawing.

Cameras—or *camerae obscurae,* as they were then called—had been in common use among artists for the past two centuries. Canaletto, for example, used a camera to paint his wonderfully detailed architectural scenes of Venice in the eighteenth century, and there is convincing evidence that the seventeenth-century Dutch painter Jan Vermeer used one in painting his

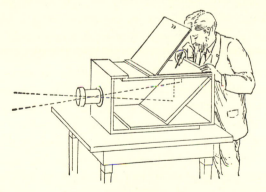

FIGURE 1

charming interiors. The painter's camera was simply a box with a lens at one end and at the other a mirror set at an angle of forty-five degrees; the mirror (Fig. 1) threw the image formed by the lens onto a ground glass on the top of the box, where a hood shielded it. The artist could study the image while he painted. If he wanted a record he would lay translucent paper on the glass and with pencil trace the image.

A Mirror with a Memory

Photography is basically a technique for recording the camera's image by chemical means or, as Daguerre put it, "by the spontaneous action of light" instead of by hand. In retrospect the technique which he worked out seems simple: the silver side of a silver-plated sheet of copper was polished mirror-bright and then placed over the top of a box containing particles of iodine. The iodine fumes, released at room temperature, produced light-sensitive silver iodide when they came in contact with the silver. The plate was then put into a lighttight box, which was fastened on the back of the camera in the exact position of the ground glass. There was a system of levers to open the cover of this plateholder inside the camera. A brass flap closed the front of the lens, and this flap could be opened to expose the plate to light for the several minutes necessary for the reaction of light and chemical. After exposure the plate was removed in semi-darkness and placed silver side down over hot mercury. The fumes from the mercury condensed on those parts of the plate which had received light, forming a whitish amalgam. The silver iodide which had not been

exposed to light was washed away with a solution of the chemical we now call sodium thiosulfate, but then was known as "the hyposulphite of soda." After a quick rinse in water, the plate was dried over an alcohol lamp.

A daguerreotype is, literally, "a mirror with a memory," to quote Oliver Wendell Holmes. On the mirror-like surface of the plate the highlights of the scene are recorded by the adsorbed mercury amalgam. The shadows of the scene have had no effect upon the plate, which remains bare in these areas. When a daguerreotype is held with the shiny surface opposite a dark field, the bare areas appear dark, and the amalgam appears white. But if a bright field is reflected, the order of light and shade is reversed: the image is negative. Thus it is incorrect to call the daguerreotype "a direct positive process," for it is ambivalent; depending on how it is viewed, it is a positive or a negative.

A Proposal to the French Académie des Sciences

When the *Gazette de France* first announced the daguerreotype in 1839, these technical details were Daguerre's secret. He had shown examples of his invention publicly, and planned to sell the technical instructions by subscription. To this end he had printed a prospectus. He abandoned the plan, however, on meeting Arago, who told Daguerre that he thought the process should be purchased by the French Government. As Director of the Paris Observatory and Permanent Secretary of the Académie des Sciences, Arago was famous in the world of science; as Deputy from the Department of Pyrénées-Orientales in the Chamber

of Deputies, he was a person of political influence. Thus he was in a splendid position to sponsor Daguerre. He learned how to make daguerreotypes and so he knew what he was talking about when, on January 7, he addressed the Académie des Sciences.

Arago explained that Daguerre had discovered "special plates . . . on which everything that the image contains is found reproduced down to its most minute detail. . . . In a word, in Daguerre's camera, light itself produces the shapes and proportions of the objects outside it, with an almost mathematical precision: the photometric relationship of the different white, black and gray parts are preserved exactly, but half tones represent red, yellow, green, etc., because the process creates drawings and not colored paintings."

The pictures Daguerre showed Arago and his associates were views of Paris: the Louvre, the Ile de la Cité, the Cathedral of Notre Dame, the river Seine and its bridges. "All these pictures," Arago said, "can be viewed with a magnifying glass without losing their purity, at least those objects which were immobile while their images were *creating themselves.*" The time of exposure varied: at noon in summer "eight or ten minutes suffice."

Daguerre not only had discovered a material of greater light sensitivity than any yet known; he had found a way to desensitize that part of the material not used. Further exposure to light would not alter the desensitized material and consequently could not destroy the image. Arago said nothing about Daguerre's technique except that it was not to be confused with the *"imperfect attempts"* to record silhouettes on silver

chloride. "That salt is white," Arago explained; "light blackens it; the white part of the image then becomes black, while the black parts on the contrary stay white. On Daguerre's plates, the drawing and the object are both alike: white corresponds to white, half tones to half tones, black to black."

Besides its obvious possibilities for recording architecture, the process seemed to Arago to offer scientists and astronomers a new tool. The Academicians were amazed that Daguerre's plates were sensitive to the feeble light of the moon. They predicted that the process would be useful in photometry.

The invention, Arago explained, was the fruit of long years of work, during which Daguerre had had the help of a collaborator and friend, the late M. Niépce. Daguerre, wondering how he could best find some recompense for his discovery and invention, soon realized that a patent would be useless, for once it was known, anybody could make use of the secret.

"It thus seems indispensable," Arago concluded, "that the Government should recompense M. Daguerre directly, and that France should then nobly donate to the whole world a discovery which can so greatly contribute to the progress of the arts and sciences."

The concern of the Académie des Sciences with the daguerreotype at once aroused the curiosity of scientists, artists, and laymen. Everybody, it seemed, wanted to know Daguerre's secret and learn how to make pictures without years of artistic training. To some, the report was electrifying, for they, too, had made similar experiments. They rushed to claim priority.

TALBOT'S DILEMMA

On January 29, 1839, William Henry Fox Talbot, an English scientist of international repute, wrote identical letters to the three members of the committee appointed by the French Academy of Sciences to investigate Daguerre's invention: Arago, Biot, and Humboldt. Talbot wrote in French, a language he knew well; we translate:

Gentlemen:

In a few days I shall have the honor of sending to the Academy of Sciences a formal claim of priority for the two principal features of the invention announced by M. Daguerre:

(1) The fixing of the images of the *camera obscura;*
(2) The subsequent preservation of the images so that they can bear sunshine.

Extremely busy at the moment with a Memoir on the subject, which will be read the day after tomorrow at the Royal Society, I must limit my-

self to begging you to accept the expression of my full respect.

> H. F. Talbot
> Member of the Royal
> Society of London

Talbot was born in Melbury, Dorset, on February 11, 1800, the son of William Davenport Talbot and Lady Elisabeth Fox Strangways.* He never knew his father, who died in July; at six months of age Henry, as he was known to the family, inherited Lacock Abbey in the village of Lacock, not far from Bath. The estate, founded in the thirteenth century by Ela, Countess of Salisbury, had come into the possession of the Talbot family when John Talbot married the niece of Sir William Sharrington, to whom Henry VIII had given it. Thus Talbot had, almost from birth, independent means. He had a good education, and was a brilliant scholar. As an undergraduate at Cambridge University, he won the Porson Prize for translating Shakespeare's *Macbeth* into Greek verse. He took his degree with honors in 1821. The following year he contributed the first of many mathematical papers to learned journals. In 1832, he was elected a Fellow of the Royal Society— the British equivalent of the French Académie des Sciences. This was no light honor, for the Society was the oldest scientific body in England, and each candidate for election was required to have six sponsors. Only fifteen members were elected each year.

* "Talbot" is the surname and "Fox" a given name—not, as sometimes assumed, the first part of a compound name.

Talbot's Achievements

Talbot conceived the idea of photography while on a holiday trip with his wife to the Italian lake country in 1833. He wanted to make pictures of the spectacular scenery, but he was no artist, and so he tried to draw with the help of a *camera obscura* exactly like the one Daguerre used. But unlike the French painter, Talbot had no experience in drawing; he found that it was not as easy to trace the image as it would seem "because the pressure of the hand and pencil upon the paper tends to shake and displace the instrument (insecurely fixed, in all probability, while taking a hasty sketch by a roadside, or out of an inn window); and if the instrument is once deranged, it is most difficult to get it back again, so as to point truly in its former direction." He did better with a *camera lucida,* which is in fact not a camera but a triangular glass prism supported over drawing paper by a brass rod. When you look down through the prism you see the view and the paper seemingly superimposed, and you trace this virtual image with a pencil. "Lucys" are still used by commercial artists.

Despite his disappointment in the camera obscura, Talbot was haunted by the beauty of the images formed on its ground glass—"fairy pictures, creations of a moment, and destined as rapidly to fade away." There must be, he thought, some more efficient way to capture these elusive images than "the faithless pencil." He reasoned that "the picture . . . is but a succession or variety of stronger lights thrown upon one part of the paper, and of deeper shadows on the

other. Now Light, where it exists, can exert an action. . . . Suppose the paper could be visibly changed by it. . . ." He resolved to make experiments along this line upon his return to England.

In 1834, Talbot worked out a way to sensitize paper with silver chloride. He put the paper in small cameras and, with exposures hours long, secured negatives. They were extremely small and imperfect. He did not carry these experiments to completion, apparently because he was preoccupied with research on a variety of subjects, ranging from optics, mathematics, and botany to archaeology and etymology.

He was deeply concerned with the phenomenon of the polarization of light, and contributed two papers on the subject to the Royal Society. Sir David Brewster, the Scottish physicist, was so impressed by Talbot's micropolariscope that, in 1837, he dedicated his *Treatise on the Microscope* to him. "In placing your name at the head of this little volume," Brewster wrote, "I express very imperfectly the admiration which I feel for your scientific acquirements, and for the zeal with which you devote your fortune and talents to the noblest purposes to which they can be applied."

In the following year Talbot received further recognition. The Royal Society bestowed its coveted Royal Medal upon him for his paper, "Researches on the Integral Calculus." Throughout this period he was in almost constant correspondence with the Italian botanist Antonio Bertolini, and he wrote the first half of *Hermes; or, Classical and Antiquarian Researches,* a most learned work, abounding in quotations from Greek, Latin, Hebrew, French, and German authors.

A Public Announcement

Now, in the winter of 1839, challenged by the news from Paris, Talbot frantically revived his interest in photography, and rushed to establish a claim of priority. He was, he later recollected, "placed in a very unusual dilemma (scarcely to be paralleled in the annals of science): for I was threatened with the loss of all my labour, in case M. Daguerre's process proved to be identical with mine, and in case he published it at Paris before I had time to do so in London."

He hurriedly got together samples of what he called "photogenic drawings" and sent them to the Royal Institution, with a request that they be shown publicly. This organization, founded by Count Rumford in 1799, was dedicated to the popularization of science; the director of its laboratory was the distinguished scientist Michael Faraday, and many important discoveries had been announced in its auditorium.* At the close of the regular Friday meeting on January 25, Faraday announced both the discoveries of Talbot and Daguerre, and invited members to view in the library specimens sent by Talbot of his pictures. *The Literary Gazette* stated: "The principal object of the exhibition of the photogenic drawings, on this occasion, was meant (as was understood) to establish a date, in order, that should M. Daguerre's discovery be made public previously to the reading, before the Royal Society, of Mr. Talbot's paper detailing his process, no charge of im-

* See *Count Rumford, Physicist Extraordinary,* by Sanborn C. Brown (Science Study Series, S28).

itation could be brought against Mr. Talbot, in case of identity of process.''

The collection, Talbot said, consisted of "flowers and leaves; a pattern of lace; figures taken from painted glass; a view of Venice copied from an engraving; some images formed by the Solar Microscope, viz. a slice of wood very highly magnified, exhibiting the pores of two kinds, one set much smaller than the other, and more numerous. Another Microscopic sketch exhibiting the reticulations of the wing of an insect.

"Finally: various pictures, representing the architecture of my house in the country; all these were made with the Camera Obscura in the summer of 1835.

"And this I believe to be the first instance on record, of a house having painted its own portrait."

He was mistaken, as we shall see later, for Nicéphore Niépce had preceded him by more than a decade. But Talbot was as ignorant of the work of Niépce as of Daguerre when he made so proud a boast.

Talbot concluded, "It is a little bit of magic realised: —of natural magic. You make the powers of nature work for you, and no wonder that your work is well and quickly done. . . . But after all what *is* Nature, but one great field of wonders past our comprehension?"

Talbot's Paper Is Read Before the Royal Society

On January 31, just six days after Faraday's announcement of the invention, the Royal Society heard a detailed description of Talbot's experiments. The paper was titled: "Some Account of the Art of Photo-

genic Drawing; or The Processes by which Natural Objects may be made to delineate themselves without the aid of the Artist's pencil.''

Talbot stated that his first plan, when he began to experiment in 1834, was "to spread on a sheet of paper a sufficient quantity of the nitrate of silver, and then to set the paper in the sunshine, having first placed before it some object casting a well-defined shadow. The light, acting on the rest of the paper, would naturally blacken it, while the parts in shadow would retain their whiteness. Thus I expected that a kind of image or picture would be produced, resembling to a certain degree the object from which it was derived. . . . Such was my leading idea before it was enlarged and corrected by experience."

This technique, known as *contact printing,* was not new. It was identical to a process worked out by Thomas Wedgwood at the turn of the century.

Wedgwood, son of the famous potter Josiah Wedgwood, had found that he could make paper light sensitive by coating it with silver nitrate. When he placed flat objects, or paintings on glass, in contact with the paper and exposed it to light, the paper darkened except where it was shielded by the objects or the painted areas of the glass. But he could not find a way to desensitize the paper after exposure, and so the pictures, which he called "profiles," gradually disappeared as the remaining silver nitrate darkened. Wedgwood also tried to record the image of a camera obscura, but did not succeed.

These experiments were published in the *Journals of the Royal Institution,* in 1802, by Wedgwood's friend and colleague the famous scientist Sir Humphry Davy,

who wrote, despairingly: "The images formed by means of a camera obscura, have been found too faint to produce, in any moderate time, an effect upon the nitrate of silver. To copy these images, was the first object of Mr. Wedgwood . . . but all his numerous experiments as to their primary end proved unsuccessful."

Talbot in his Royal Society paper acknowledged Wedgwood's priority, and quoted two paragraphs from Davy's account. He said that he was unaware of this work when he began his experiments, but had already worked out a technique for *"fixing* the image in such a manner that it is no more liable to injury or destruction" and had found a way to record the camera's image. It was, he thought, fortunate that he knew nothing of Wedgwood's failure, for he might well have abandoned his own work, "when so distinguished an experimenter as Sir Humphry Davy announced that all experiments had proved unsuccessful."

At this time Talbot did not divulge his technique to the Royal Society. He did, however, describe his reasoning:

"The nitrate of silver, which has become black by the action of light, is no longer the same chemical substance that it was before. Consequently, if a picture produced by solar light is subjected afterwards to any chemical process, the white and dark parts of it will be differently acted upon; and there is no evidence that after this action has taken place, these white and dark parts will any longer be subject to a spontaneous change; or, if they are so, still it does not follow that that change will *now* tend to assimilate them to each other. In case of their remaining *dissimilar* the picture

will remain visible, and therefore our object will be accomplished. . . .

"My first trials were unsuccessful, as indeed I expected; but after some time I discovered a method which answers perfectly, and shortly afterwards another. . . .

"This chemical change, which I call the *preserving process,* is far more effectual than could have been anticipated. The paper, which had previously been so sensitive to light, becomes completely insensible to it, insomuch that I am able to show the Society specimens which have been exposed for an hour to the full summer sun, and from which exposure the image has suffered nothing, but retains its perfect whiteness."

Talbot considered this invention of a fixing technique "new proof of the value of the inductive methods of modern science, which by noticing the occurrence of unusual circumstances (which accident perhaps first manifests in some small degree), and by following them up with experiments, and varying the conditions of these until the true law of nature which they express is apprehended, conducts us at length to consequences altogether unexpected, remote from usual experience, and contrary to almost universal belief."

The rest of Talbot's report to the Royal Society described a number of applications of his process: the copying, by contact printing, of engravings and pages with type or writing on one side only; the recording of the optical image of the microscope and, finally, of the camera.

"Not having with me in the country a *camera obscura* of any considerable size, I constructed one out of a large box, the image being thrown upon one end

of it by a good object glass fixed in the opposite end. This apparatus being armed with a sensitive paper was taken out in a summer afternoon and placed about one hundred yards from a building favourably illuminated by the sun. An hour or two afterwards I opened the box, and I found depicted upon the paper a very distinct representation of the building, with the exception of those parts of it which lay in the shade."

Talbot explained that although the lights and shadows were reversed in his photogenic drawings, this transformation could be corrected quite simply by putting the reversed drawing in contact with a fresh sheet of sensitized paper to make a new re-reversed picture. Thus the original picture was a *negative,* the picture made from it was a *positive.* To Talbot goes credit for discovering this *negative-positive* principle, upon which most subsequent photographic systems have depended.

The Royal Society meeting was reported in the press. *The Literary Gazette* of February 2, 1839, carried an abstract, written by Talbot himself, of his formal paper. The entire paper appeared in *The Athenaeum* for February 9, in *The Mechanics' Magazine* a week later, and in *The London & Edinburgh Philosophical Magazine.* It was reprinted by Talbot as a fourteen-page pamphlet for private distribution; in this form it is the first separate publication on photography in the world.

Thus Talbot staked his claim in England.

NIEPCE: THE ALMOST-FORGOTTEN PIONEER

Talbot's challenge forced the French to counter by revealing the pioneer work of Nicéphore Niépce,* whom Arago in his preliminary announcement of the daguerreotype, had so summarily dismissed as Daguerre's "collaborator and friend." The contribution of Niépce was of much greater importance than the public knew.

Arago was puzzled when he received Talbot's letter claiming priority, for he did not know whether it was addressed to him personally or to him as Permanent Secretary of the Académie des Sciences. When he learned that both Humboldt and Biot had received the identical letter, he considered it an official claim for priority. Humboldt was angered by the letter, which he called arrogant. Biot wrote Talbot pointing out, "in case you are unaware of it," that Daguerre's friends knew that his researches had begun fourteen years ago. He concluded most respectfully: "I hasten to send you this statement, Monsieur, so that you may judge the facts yourself. I do so as much out of the

* Pronounced "nyĕps."

esteem which your previous work on optics has aroused in me, as in the confidence which you have shown me."

At the February 4 meeting of the Académie, Arago read Talbot's challenge. He stated that the Académie had legal proof that Daguerre's late partner, Nicéphore Niépce, as early as 1822 had devised a technique for producing permanent images by light action—a technique "which we will make known in the proper time and place." He announced further that the Académie would publish the partnership agreement between Niépce and Daguerre, dated December 14, 1829, and that they would prove, by Niépce's own letters, that Daguerre had already worked out "the entirely new process which he uses today" before the partner's death in 1833.

Nicéphore Niépce was born in 1765 in Chalon-sur-Saône, a city in the heart of France, some 145 miles southeast of Paris. When the fury of the French Revolution descended upon France, his father, known to be a man of wealth and suspected of Royalist tendencies, fled with his family. Nicéphore served briefly in Napoleon's army. When he was mustered out, because of ill health, he settled in Nice and married. In 1801, he returned to Chalon-sur-Saône, where he had not only a town house but a country estate at Le Gras, in the village of Saint Loup de Varenne, just a few kilometers outside the city. He spent the rest of his life in research.

With his brother Claude, Nicéphore invented an internal combustion engine which they named the Pyré-lophore, a combination, they explained, of Greek words meaning "fire," "wind," and "I produce." Air

was forced into a cylinder fitted with a piston. At the bottom of the cylinder was a flame. A charge of combustible powder was forced into the cylinder. The powder instantly exploded, with such force that the piston was pushed upwards with a thrust claimed to be fifty-seven kilograms. As the piston returned, the expended gas was forced out. Their first fuel was lycopodium powder—highly inflammable plant spores commonly used in fireworks. Later they substituted lampblack mixed with finely ground resin. Although the engine was powerful enough to drive a boat up the Saône River at a speed "twice that of the current," nothing ever came of the ingenious and prophetic invention, so closely paralleling in principle the gasoline engine.

Early Experiments with Lithography

Claude moved to Paris in 1816; the brothers thought the chances of promoting the Pyrélophore were better in the capital. Nicéphore was then experimenting with lithography, a method of reproducing drawings or printed matter. This graphic arts process, which gave astonishing fidelity, was then quite novel. It was invented by Aloys Senefelder in Munich, in 1798, and was based on the principle that a certain local slate, Solenhofen stone, absorbed both water and grease. The artist, using a greasy pencil or fatty ink, drew the picture on the stone. Each mark he made was immediately absorbed. The stone was then wetted. The water was absorbed by the bare stone but repelled by the grease or fat in the drawn marks. Greasy ink was next rolled over the stone. The drawn areas attracted

the ink; the wet stone repelled it. Thus every part of the stone that had been drawn upon held ink, while the bare areas remained bare. Paper was now laid over the stone and with a scraper pressed into firm contact. The ink was thus transferred to the paper, which received a facsimile of what the artist had drawn.

Niépce hoped to find a light-sensitive varnish with which he could prepare a lithographic stone for inking; he wanted to be able to contact print a drawing or an engraving on the stone, with the picture oiled to make it translucent. He kept his brother Claude posted on his experiments in frequent letters, and about all we know of this work is based on evidence which is incomplete, often confusing, and generally inconclusive.

Niépce Makes a Paper Negative

By 1816, Niépce had extended his experiments. He now began to try to record a camera image. On April 12 of that year, he wrote his brother: ". . . I've had a kind of artificial eye made that is quite simply a little square box six inches on each side fitted with an extension tube that carries a lens." He accidentally broke this camera, but built others. He reported on May 5: "I put the apparatus in the room where I work in front of the window opposite the birdhouse. I made the experiment with the process that you know, *cher ami,* and I saw on the white paper all the parts of the birdhouse that can be seen from the window and a faint image of the windowsills which were less illuminated than the objects outside. . . . This is still but an imperfect attempt. . . . The possibility of painting this

way seems to me almost demonstrated. . . . What
you expected happened. The background of the pic-
ture is black, and the objects are white, that is to say
lighter than the background. . . . Perhaps it will not
be impossible to change this disposition of the col-
ors. . . ." Two weeks later he told his brother that
three improvements were needed: greater sharpness
of image, "transposition of the colors," and a means
of fixing the colors. The last, he said, would not be the
easiest. "But, *mon cher ami,* as you have well put it,
we don't lack patience, and with patience anything can
be done."

He sharpened the image by putting a circular mask
on the lens to reduce its aperture. He sent four pic-
tures made with this arrangement to Claude. They
could hardly have been successful, for he had to de-
scribe what was shown in them. They were negatives,
and he again complained: "The effect would be more
striking if . . . the order of shadows and highlights
could be inverted; that is what I am going to work on
before trying to fix the colors, and that is not easy."

In these experiments, Niépce apparently used silver
chloride or, to use the nomenclature of the day, "mu-
riate of silver," as the sensitizing material; at least
some of his early experiments were made with this
substance, for on April 20, 1817, he wrote his brother,
"I have given up the use of muriate of silver." Thus,
without knowing it, he was following in the foot-
steps of Wedgwood. He succeeded, where Wedgwood
failed, in recording the camera image. But he failed,
as Wedgwood too had failed, in finding a way to make
the image permanent. "This kind of picture, I think,
alters in time even though one takes care not to put it

in contact with light. . . ." Even though the negatives were fugitive, a great step forward had been taken. Niépce was the first man in history to record the camera image *"spontaneously* by the action of *light."*

The Search for a Direct Positive System

Bothered by the inversion of light and shade, which to him was "unnatural," and unaware that simply by contact printing the negative he could secure unlimited positives, Niépce now began to search for a substance that light would bleach, not darken.

He found that "the black oxide of manganese" (manganese dioxide) became white in contact with chlorine. If the bleaching was begun by chlorine, it could be completed by light. He built a camera that was airtight as well as lighttight and pumped chlorine into it while the manganese dioxide was exposed. But the technique did not work, and he gave it up.

Then, in 1817, he reported: "I read in a book on chemistry* that the resin guaiacum, which is yellow gray, becomes a very beautiful light green when exposed to light, that it then acquires new properties, and that to dissolve it in this state, a more rectified alcohol is required than that which dissolves it in its natural state."

His first attempt to use resin was unsuccessful, and he abandoned it in favor of phosphorus. "It is naturally yellowish," he wrote Claude, "but melted in hot water it becomes almost as white and as transparent as the glass, and then it is perhaps more sensitive

* Possibly Jean Senebier's *Expériences sur l'action de la lumière solaire dans la végétation* (Geneva 1788).

than silver chloride itself to light." Phosphorus is a dangerous and highly poisonous chemical, difficult to handle; it bursts into flames in contact with air and must be kept under oil. Niépce devised a way of handling it inside a box by remote control, but had great difficulty coating the stone "plates" he was using. After three months of experimentation, he gave up what he called "this perfidious combustible." All he had gained was a severe burn on the hand.

Claude moved to London in hope that the British, who had developed steam power, might show more interest in the internal combustion engine than the French had. The brothers continued to correspond, but since Claude advised the use of the most guarded terms in describing the photographic work, for fear that the letters might be opened and the secret lost, the few letters that exist tell but little beyond the fact that Nicéphore was making progress. An anecdote, recounted years later by his son Isidore, indicates that Niépce was making transparencies on glass. According to this account, a relative, one General Poncet de Maupas, visited Niépce, in 1822, and was enthusiastic about his latest success—a copy photograph on glass of an engraved portrait of Pope Pius VII. Isidore recollected that this picture was made with a light-sensitive resin—bitumen of Judea. Niépce generously gave the picture to the general, who had it framed in Paris at the shop of Alphonse Giroux, where it was greatly admired. Unluckily the general dropped the picture one day, and it was smashed; only the frame survived, which Niépce's son Isidore, somewhat forlornly, produced years later as evidence that the picture once existed.

Photogravure—Light Does the Work of the Artist

Beginning in 1824, references to photography became more frequent in the brothers' correspondence. Niépce described etching stones with acid. He sent one of them to a lithographer to be printed. The lithographer was baffled, for he saw no drawing on the stone or other evidence of treatment, and concluded that it had been poorly prepared. Niépce told him that his process was not lithography, and that the stone should be printed like an etching.

The classical way of making an etching, unchanged since the day of Rembrandt, consists of five steps:

1. A copper plate is coated with an acid-proof ground composed of wax, gum, and asphalt or bitumen.
2. The artist draws on the coated plate with a stylus, which removes the ground, so that the copper is laid bare. The drawing appears as copper lines against the ground, which commonly is blackened, so the artist can see the progress of his work.
3. Nitric acid is carefully poured on the plate. The acid, called by etchers a *mordant,* attacks the copper, forming furrows wherever the artist has drawn lines.
4. The ground is removed and the copper plate polished.
5. The plate is covered with ink and the surface wiped clean. Ink remains in every etched line. Paper pressed against the plate absorbs the ink. The result is an exact record of the artist's drawing.

Niépce discovered that bitumen of Judea, a form of asphalt commonly used by etchers, is light sensitive, much as guaiacum is. Normally it is soluble in lavender oil. On exposure to light, however, it becomes insoluble in that liquid. This observation enabled him to make light do the work of the artist.

At first he used stone for his "plates." Later he used pewter and copper. Like every etcher he coated the plate with bitumen. But instead of drawing a picture by hand he took an existing picture, an engraving or a lithograph which he had varnished to make it transparent. He laid this prepared picture in contact with the coated stone, and then exposed it to light. Each inked line of the print held back the light, and the bitumen beneath it was unaltered. But light passed through the bare paper of the print and made the bitumen beneath it insoluble. Niépce now washed the stone with oil of lavender: the unexposed bitumen, representing each line of the picture he copied, was dissolved. He now followed steps 3, 4, and 5 of the classical procedure for biting the plate, inking it, and printing it.

What Niépce discovered came to be called *photogravure*. The principle of a light-sensitive resist is the basis of all the photomechanical arts which enable us to reproduce pictures on a printing press. In retrospect, this was Niépce's greatest contribution. His technique was practical; he made many reproductions which approach facsimiles of prints. Although no commercial use was made of the invention in Niépce's lifetime, his nephew, Claude Abel Niepce de Saint-Victor, revived it in 1853, and perfected it as "heliogravure." The asphalt process, as it was also called,

was used by printers for decades. The importance of this discovery has been lost sight of, largely because Niépce himself considered it but a step toward his goal, which was to capture, somehow, camera pictures of the natural world.

He reported success on September 16, 1824. "I have the satisfaction of being able to announce to you at last," he wrote Claude, "that with the perfected processes I have succeeded in getting a picture from nature as good as I could desire and yet I hardly dare flatter myself because up to now I've had only the most incomplete results. This picture was taken in your room on the side toward Le Gras, and I used my biggest C.O. [camera obscura] and my biggest stone. The image of the objects is represented with sharpness, astonishing fidelity even to the least details, and with the most delicate nuances. As this counterproof is barely colored you can judge the effect only by looking at the stone obliquely; then it becomes visible to the eye, by means of shadows and reflections of light, and this effect, I can tell you, *cher ami,* is really something magical." So close did Nicéphore feel to success, he told Claude, that he would insist upon publishing the process under both their names.

HELIOGRAPHY

In the fall of the following year, 1825, Niépce bought a prism from Vincent Chevalier, the leading optician in Paris. The messenger who picked it up told Chevalier about Niépce's success in fixing the image of the camera obscura on any substance. "This discovery seemed to me so astounding that I thought he was mistaken," Chevalier wrote Niépce, "and at least until you confirm it I still won't believe it!"

Shortly afterwards, Niépce received a letter from Daguerre, stating that he had been working along similar lines for some time, with little success; he wondered whether Niépce was having better luck. The letter does not exist because Niépce lost it. But he recollected that it was a strange and confusing message, and he was puzzled. He had no idea of how Daguerre had come to know of his work. Years later the answer came: Chevalier's son Charles had been the informant.

Niépce was suspicious, for Daguerre was unknown to him. He wrote a polite yet evasive acknowledgment,

and there, he thought, the matter would end. But a year later, in January 1827, Daguerre wrote again, asking for a sample picture. Niépce was bothered, and he asked the engraver Augustin François Lemaître whether he knew Daguerre and if so, what he thought of him. Lemaître answered that he was aware of Daguerre's interest in cameras, but did not know precisely what he was doing with them. He advised Niépce to break with him: "Sometimes it takes very little to get on the track of a discovery."

Niépce was now etching pewter plates, and he had sent five of them, all reproductions of pictures, to Lemaître for his opinion of their quality. In the same letter in which he asked about Daguerre he said that as soon as summer came with its brilliant sun he was going to concentrate on taking pictures of nature with his camera.

Lemaître replied that he thought the plates were too lightly etched, and he regretted that Niépce used soft pewter instead of hard copper. Niépce's announcement of taking pictures from nature brought forth an enthusiastic response: "I hope with all my heart that your attempts will be crowned with full success, because that is a discovery which should be of great utility to the arts and which might make as much of a sensation as did lithography on its appearance. . . ." He was less optimistic about Niépce's gravure reproductions, and offered to retouch the plates. In reply to Niépce's offer to share with him whatever material advantages might come of the discovery if he chose to become an associate, Lemaître expressed thanks and offered to help.

Niépce Pays a Visit to Daguerre

No sooner had Niépce received Lemaître's advice to break with Daguerre than he received from that artist a framed picture. It looked like a sepia drawing. Daguerre said it was "finished by my process" and he called it a *dessin-fumée,* a "smoke drawing." In exchange Niépce sent Daguerre an engraved pewter plate. "This communication cannot in any way compromise the secret of my discovery," he explained to Lemaître.

In the summer of 1827, Claude's health, long poor, took a turn for the worse, and Nicéphore and his wife went to England to be with him and to offer what help they could. On the way they stopped in Paris, where Niépce met Daguerre for the first time. He was much impressed with the Diorama. Daguerre also showed him some of his photographic experiments, which Niépce found quite different from his own. He wrote his son Isidore: "M. Daguerre has succeeded in fixing on his *chemical substance* some of the colored rays of the prism; he has already fixed four, and is working to fix three more to have the seven primary colors." Daguerre did not disclose the nature of his "chemical substance," but Niépce guessed that it was some phosphorescent material such as finely crushed and calcined barium sulfate, then called "Bologna stone." Years later, when the French Académie des Sciences published this technique of Daguerre's, this assumption was proved to be correct. "It has a great attraction for light," Niépce wrote, "but cannot hold it long. . . . From what he said to me, he had little hope of

success, and his research is little more than a curiosity. My process seems to him preferable and much more satisfactory. . . ."

When Niépce and his wife arrived in Kew, they found Claude's health even worse than they had expected. He not only suffered from what they described as dropsy, but was mentally disturbed. In his mind the Pyrélophore had become the secret of perpetual motion. His thinking was no longer rational, and though his family did not know it, his days were numbered.

Niépce Meets Discouragement in England

While in England on this sad mission, Niépce tried in every way he could think of to promote his invention, which he now called *heliography*. He wanted to show the King some of his heliographs, and asked William T. Aiton, the director of Kew Gardens, to help him. The pictures were sent to Windsor Castle. Niépce never heard whether the King saw them; they were returned with the suggestion that the proper channel for the presentation of his discovery was the Royal Society.

Aiton then introduced Niépce to his colleague Francis Bauer, who was a member of that august body. Bauer, a neighbor in Kew, was greatly impressed by the heliographs and became Niépce's champion and friend. At his suggestion Niépce wrote a memoir on heliography, which he hoped to present to the Royal Society.

Niépce gave Bauer four heliographs. Three of them were copies of prints. On the back of the fourth Bauer wrote in French and English: "Monsieur Niépce's first

successful experiment of fixing permanently the Image from Nature. 1827." This picture (Plate 11), lost for decades, was rediscovered in 1952 by Helmut and Alison Gernsheim; it is now at the University of Texas.

The image, which is very faint and can be seen only in raking light, shows the courtyard of Niépce's estate, Le Gras, in the village of Saint Loup de Varenne, near Chalon-sur-Saône. Due to the extreme length of exposure, which lasted from dawn to dusk, the shadows were obliterated as the sun moved from horizon to horizon. Unless one knows where it was made, it is hardly possible even to guess what it represents. This is how the Gernsheims interpret it: "On the left is what the brothers called the pigeon house . . . to the right of it a pear-tree with a patch of sky showing through an opening in the branches, in the middle the slanting roof of the barn. The long building behind it is the bakehouse, with chimney, and on the right is another wing of the house."

The heliograph is on a pewter plate, $6\frac{1}{2}$ by $8\frac{1}{2}$ inches. This fact has led the Gernsheims to date its production in the year 1826, when Niépce wrote his son Isidore that he was using pewter plates as a base for the light-sensitive bitumen. Certainly, the picture could not have been produced earlier, but it might well have been made any time before the day in August 1827 when Niépce left Chalon for England.

Niépce showed his heliographs to all the scientists he could meet. He asked Joseph Constantine Carpue, a distinguished surgeon, for advice about presenting his invention to the Society of Arts. Carpue put him in touch with an optician named Watkins: "I think,"

Carpue wrote, "an arrangement with this gentleman will be much more advantageous to you than the Society of Arts, but, however, if after an interview with him you still want the letter you have asked me for, you have only to let me know, and I will rush it off to you." Niépce sent Watkins a copy of his memoir. It was in French. Mrs. Watkins translated it for her husband, who asked her to write Niépce that he felt the process was more related to engraving than to optics.

Niépce then got in touch with R. Ackermann, who was the publisher of the first English translation of Senefelder's *A Complete Course of Lithography,* and whose Repository of the Arts was the leading art supply house in London. He proposed the formation of a company to exploit the invention when it would be perfected. Nothing came of the proposal.

Through Bauer, Niépce got a letter of introduction to Thomas Young, secretary of the Royal Society. This distinguished scientist, whose famous experiment on interference established the wave property of light, reported: "Mr. Nepce's [sic] invention appears to me to be very neat and elegant and I have no knowledge of any similar method having been before employed. How far it may become practically useful hereafter is impossible for me to judge, especially without knowing the whole of the secret. But I see no reason to doubt of its utility, except that all novelties are liable to unforeseen difficulties."

Encouragement from Daguerre

After five months of running from door to door, only to meet with complete frustration and bitter dis-

appointment, Niépce received a warm and friendly letter from Daguerre, dated February 3, 1828. "I am sorry to see . . . that you have had nothing but discouragement in England, but be consoled; it is not possible that it should be the same here, especially if you arrive at the results that you have every right to hope for. . . . It would be a real pleasure to me, if you would find it agreeable, to show you how to get the most from your discovery. I cannot hide the fact that I am burning with desire to see your experiments from nature."

Niépce and his wife left England at once.

Only a few days later, on February 10, Claude died.

PARTNERSHIP BY CORRESPONDENCE

New Lenses from Chevalier

On his way home, Niépce stopped in Paris, saw Daguerre again, and ordered two lenses from Chevalier.

The first of these was a lens designed by Thomas Wollaston especially for the camera obscura. He named it a "periscope." It was a single concavo-convex lens, or meniscus, put in the camera with the concave side behind a diaphragm facing the object. In Wollaston's first description of the lens, in the *Philosophical Transactions* of the Royal Society for 1812, he showed it in a vertically positioned camera obscura fitted with a mirror. Artists favored this style which is shown in Figure 2. This simplest of all camera lenses is effective only when the aperture is small, on the order of $f/11$;* consequently the image lacks brightness. It is made of

* In photographic optics, the aperture of a lens is measured by the ratio of its effective diameter to its focal length. This is called the *f number*.

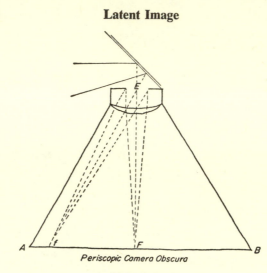

Periscopic Camera Obscura

FIGURE 2

one kind of glass only, and thus is not achromatized, that is, color corrected.

The second lens Niépce ordered from Chevalier was an achromatic triplet. Chevalier sent it to him disassembled and enclosed a note with a diagram showing him how to put the three elements together as in Figure 3a and b. "We have sent you today by Royal Stage Coach the three-element achromatic objective of 12-

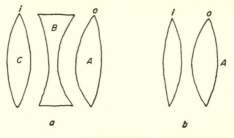

FIGURE 3

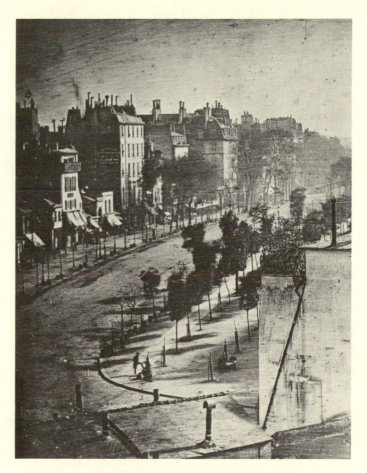

1. Boulevard du Temple, Paris. A detail of one of
Daguerre's earliest daguerreotypes, taken in the Fall of
1838. Bayerische Nationalmuseum, Munich.

2. Camera obscura owned by H. Fox Talbot. Replica, in George Eastman House, Rochester, N.Y.

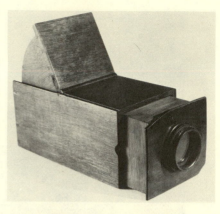

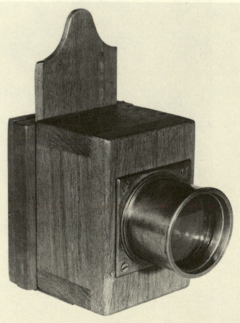

3. Camera built for Talbot for his early experiments. The objective is a series of four biconvex lenses. George Eastman House, Rochester, N.Y.

Latticed Window
(with the Camera Obscura)
August 1835

When first made, the squares
of glass about 200 in number
could be counted, with help
of a lens.

4. The earliest existing negative, by Talbot. 1835. The Science Museum, London.

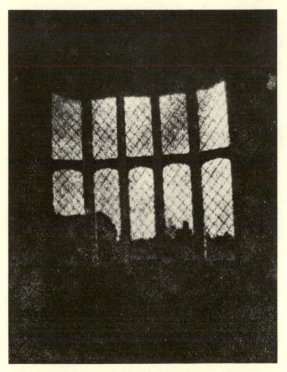

5. Modern enlargement from Talbot's 1935 negative. The Science Museum, London.

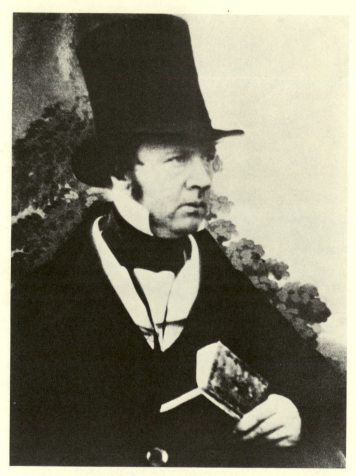

6. William Henry Fox Talbot. Daguerreotype by Antoine Claudet, Daguerre's English licensee. The Royal Photographic Society, Bath, England.

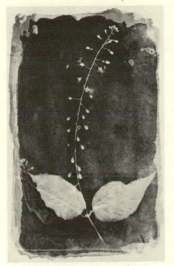

7. Photogenic drawing by Talbot, about 1836; made by laying the plant on sensitized paper. Collection of Harold White.

8. Lace, at 20X magnification. 1839. Paper negative. The Royal Photographic Society, Bath, England.

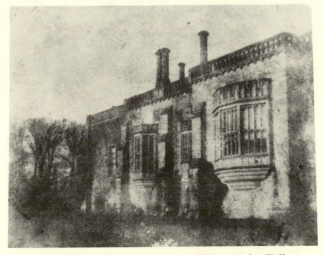

9. Lacock Abbey. A photogenic drawing sent by Talbot to the Italian botanist Antonio Bertolini on August 21, 1839. The Metropolitan Museum of Art, New York.

10. Nicéphore Niépce. Plaster bust by Jean August Barre, 1853, from a profile drawing by Isidore Niépce. George Eastman House, Rochester, N.Y.

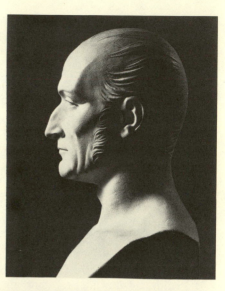

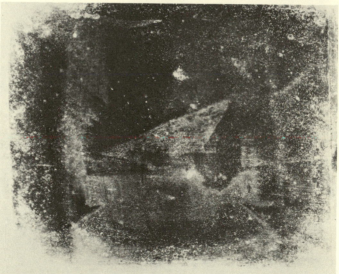

11. View from a window at Le Gras into the farmyard. Niépce's first heliograph from nature, taken between 1826 and 1827. The photographic copy was made from the original, now in the Gernsheim Collection of the University of Texas at Austin, by the Research Laboratory of Kodak, Ltd.

12. Lithograph by Jean Philippe Schmit (1790–1832) from a drawing by Daguerre of his stage set for the play *Elodie* at the Théâtre de l'Ambigu Comique, Paris. George Eastman House, Rochester, N.Y.

13. Heliograph copy by Niépce of the lithograph of Daguerre's drawing. Presented by Niépce to Francis Bauer in 1827. The Royal Photographic Society of Bath, England.

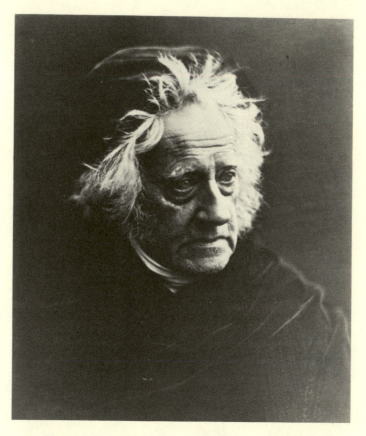

14. Sir John F. W. Herschel. 1867. Photograph by Julia
Margaret Cameron. George Eastman House,
Rochester, N.Y.

inch focus and 3-inch diameter, with an invoice in the
sum of 102 francs. Note that the surfaces that should
be put together are marked O and I. Lens A should
be toward the object and C should be toward the
[ground glass] screen, the surfaces of the three glasses
being put together. . . ."

This $f/4$ lens is a common telescope objective.
Since we know neither the refractive indices of the
glasses used by Chevalier nor the exact radii of the
elements, its efficiency cannot be predicted. It is ob-
vious, however, that the image would show marked
curvature of field, an aberration that could not be cor-
rected by a diaphragm because both outer surfaces
are convex. It would appear to be an unsuitable lens
for photographic purposes.

Niépce wrote Bauer that he got these two different
types of lenses in order to compare them. After a
few months' trial, he found the periscope so much
better than the triplet that he asked Chevalier to make
him one of 24-inch focal length and 6 inches in diame-
ter. Chevalier said such a lens would be excessively
expensive; he suggested that Niépce use a biconvex
lens which would cost only half as much and, in his
opinion, would be equally good.

At this time Niépce was starting to use silver-plated
copper plates, instead of pewter, as the base for his
sensitive bitumen. Chevalier got them for him from a
silversmith, who guaranteed them to be flat, well pol-
ished, of uniform size, and of mark 20; that is, the
silver plate to be one twentieth of the total thickness.
He was also using glass plates in an effort, he said, to
imitate the effects of the Diorama. He discovered, to
his astonishment, that some of his images showed

colors, which he attributed to the interference patterns known as Newton's rings. Although he never succeeded in recording all the colors of the spectrum, he clearly defined the problem which Gabriel Lippmann, in 1891, was to solve with an interference process of color photography.

By 1829 Niépce felt ready to write a book about his discoveries. Several drafts of his outline exist. In contrast to the deliberately vague references in his correspondence, the outline is logical, simple and direct. He planned to describe the light sensitivity of iodine, guaiacum, silver chloride, bitumen of Judea (asphalt), "manganese peroxide," and certain animal oils. It would have been an astonishing book. He never wrote it. Daguerre advised him not to; other ways, he said, could be found for exploiting his discovery.

Niépce had written Daguerre early in 1829, but, to his disappointment, months went by before he received an answer. Daguerre apologized: he had not been able to work on his "experiments with light" because his time had been taken up painting the enormous canvases for the Diorama and in business travel. He was delighted to learn that Niépce had met with success, and would be happy to see one of his pictures. Niépce sent one for criticism and asked him to show it to Lemaître. Both sent remarkably detailed and perceptive criticisms.

The picture, they said, lacked tones; only three or four could be distinguished. They thought the etching process might be at fault, and Daguerre urged him to abandon that practice. The process needed improvement to get better tone reproduction: "When one realizes that the merest schoolboy with the help of a cam-

era obscura can draw and tint with no less exactness,"
Daguerre wrote, "perfection is needed." Better optics
were required. Above all, the time of exposure must
be reduced. The passage of the sun across the sky
during the long exposure needed for Niépce's picture
had left parallel walls equally lighted. Both Daguerre
and Lemaître closed their letters with warm and gen-
erous offers to help.

The Partnership Is Formed

Niépce took the criticism well. His only objection
was that both correspondents were incorrect in assum-
ing that the plate was etched. It was not touched by
acid, but darkened by a new technique. In his letter
to Daguerre he reminded him of discussions they had
had in Paris about collaboration, and now offered to
take both Daguerre and Lemaître in partnership.

Daguerre answered that he would be delighted to
join Niépce. He was designing a new lens, an achro-
matized triplet, which would give "more field" and be
more powerful by a factor of 3. Niépce had suggested
retouching plates. Daguerre was shocked. He had
come to respect the camera image for its own sake,
and depended upon its revelation of detail to create
that sense of realism upon which the Diorama de-
pended for its success. "Nature has her artlessness,
which must not be destroyed," he wrote, with extraor-
dinary perception of that esthetic of the camera which
decades later came to be called "straight photography."

The immediate acceptance of his proposal led
Niépce to have his lawyer draw up articles of partner-
ship for the firm of Niépce, Daguerre, and Lemaître.

On receiving the papers, Daguerre asked Niépce if he had committed himself to Lemaître. If not, he suggested dropping him; he thought Lemaître's skill as an engraver was not needed and, for reasons of security, he regretted having to disclose their secret to a third party. He proposed that the process be published as the invention of Niépce, perfected by Daguerre, and enclosed an alternate draft for a contract. Niépce spoke to Lemaître, who agreed to forego partnership, but asked for the exclusive right to do whatever engraving might be needed. Niépce then prepared for Daguerre a detailed description of his bitumen-of-Judea process.

On December 10, 1829, Daguerre left Paris by stage coach and arrived in Chalon three days later. On the 14th, the contract was signed, and Daguerre returned to Paris. He never saw Niépce again. Their collaboration was entirely by correspondence.

Secret Collaboration

For the first time in his long years of perseverance, Niépce now had a hard-working helper. No longer was he alone. Daguerre's first contribution was to draw up a numbered list of words and phrases. Apparently this was to be both a kind of shorthand and a secret code. Each letter to Niépce was headed by a list of new words. These were not numbered but were to be added in chronological order to the basic list. Thus secrecy was maintained, for even if one letter fell into unfriendly hands, its contents would be incomprehensible without the basic list.

A typical paragraph reads:

"Like you, Monsieur, I have noted that 6, 7, 8, 9, and 10 are null in the operation, because they separately leave no trace with 1 or 44. 5 seems to me as to you to have the properties except for 52."

Here are the code words:

1. Oil of lavender	8. Lac
5. Bitumen of Judea	9. Wax
6. Sandarac	10. Copal
7. Mastic	44. Dippel oil
	52. White

The letters bristle with experiments. Daguerre asks whether Niépce has noted the effect of electric current on the sensitivity. He reports recording the image of the solar microscope, and sends one of the instruments to Chalon, with a drawing explaining its optics. On May 10, 1831, Daguerre made an observation that was to become vital: "I have made several trials of 20 [iodine]; this substance is very sensitive to 46 [light]." Niépce, it will be remembered, had included iodine among the light-sensitive materials he was going to write about in his proposed book. But Niépce was mistaken in believing that the element iodine is light sensitive. Like its sister halogens, chlorine and bromine, it is light sensitive only in certain compounds, notably with silver. Niépce used iodine fumes to darken the areas of his silver plate, which had been laid bare by dissolving the unexposed resin coating. The iodine combined with the silver to form silver iodide. But light promptly reduced this salt to silver, in finely divided state, which absorbed rather than reflected light and so appeared dark.

In his next letter, dated May 21, Daguerre describes

this salt. "I think after many new tests that we ought to concentrate our researches on 20 [iodine]. This substance is highly light sensitive when it is in contact with 18 [silver plate]. But there is a degree which should not be exceeded, that is to say the 18 [silver plate] should be taken out as soon as it has a beautiful and uniform gold tint because it then passes to different bluish and bronze colors which do not have the same sensitivity to 46 [light]. I have obtained in this gold tint on the 18 [silver plate] results of satisfying speed, that is less than 3 minutes in the 13 [camera], 29 [engravings] in the 56 [sun] in one minute and in the microscope in two minutes." He noted that the tones were reversed and regretted he had not yet found a technique for fixing the image.

One possible solution for transposing the lights and shadows occurred to him. When he exposed a silver iodide plate beneath an engraving for an hour instead of a minute, he noticed the tones of the print were reproduced light for light and dark for dark in deep blue, "just like a blossom on one of Monsieur's plum trees." He suggested that "it would not be a loss of time to work with this substance."

Daguerre had observed the phenomenon of solarization: the reversal of tones by extreme overexposure. He was not to use this phenomenon. But all his subsequent work was based on his remarkably perceptive observations on the properties of silver iodide.

Although Niépce had experimented with iodine, he was unsuccessful. He reminded Daguerre of his failures: "I had dealt with this same experiment before having become associated with you, but with no hope of success, because I considered it an almost impos-

sible matter to fix the exposed images in a lasting man-
ner, even if we should succeed in keeping light and
shade in their proper arrangement. . . . I made new
experiments with iodine last year, after your departure
from here, but according to another procedure; after
I had reported the results to you and received your
unsatisfactory reply I decided to discontinue my ex-
periments. It seems that you meanwhile regard this
question from a more hopeful point of view. . . ." He
renewed experiments, but with no success, and in No-
vember declared the thing impossible.

On October 3, 1832, Daguerre reported that he had
designed a new 6-inch lens: "a two-element cemented
achromat forming nothing more than a periscopic
curve. It needs a diaphragm the opening of which is
determined by the diameter of the lens. The sharpness
even surpasses that which we have obtained by con-
tact printing 29 [engravings]." He liked the new lens
so much he put all his others away, and sent a sketch
of it (Fig. 4) to Niépce, pointing out that the convex

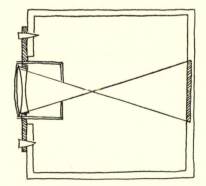

FIGURE 4

side of the lens should face the object, and the concave side, the plate.

On June 6, 1833, Daguerre wrote that glass seemed better, after all, than silver plates, for the latter tend to oxidize. He was concerned that he and Niépce had to use different sources of water, and regretted that things were going so poorly with the Diorama that he could not afford to travel.

On July 5, 1833, suddenly, Niépce died of a stroke. He was sixty-nine years old.

THE DAGUERREOTYPE

The death of his partner stunned Daguerre. "I loved Monsieur Niépce as much as if he had been my father!" he wrote Isidore. "This blow is as terrible for me as for you, yes, I write you with my eyes wet with tears. . . . We must redouble our efforts so we can immortalize his name by publishing his discovery."

Neither had the heart to set to work again until the following year. Daguerre soon found out that Isidore was not of the stature of his father. Daguerre had his living to make, and painting the Diorama picture *The Midnight Mass* was exhausting. "From six in the morning to six at night I've been working on my painting," he wrote Isidore, "but you haven't done a thing, it seems to me; I ought to scold you, because you know we must have a large number of perfect pictures before we can publish anything. . . . So you see, *mon cher* Isidore, you've got to work hard."

Development by Mercury Vapor

Apparently Daguerre had made the second discovery basic to his perfected process in 1835: the after-treatment of the exposed silver iodide plate with mercury vapor, which produced a whitish amalgam on the exposed areas of the plate. It was, in a sense, "development." Light acting on the silver iodide reduced that compound to free silver; mercury atoms were adsorbed on the surface of the plate at these nucleated areas. The mercury had no effect on the unexposed areas, which remained silver iodide. It is not clear how Daguerre fixed his first plates; possibly by treatment with a strong solution of sodium chloride, thus forming a complex iodide-chloride silver salt of relatively low light sensitivity. Theoretically, fixing was hardly a critical matter; since the unexposed silver iodide represented the shadows of the picture, their subsequent darkening by light would only increase the difference in brightness of highlight and shadow.

This discovery of what came to be called "mercurializing" is not documented. There is a picturesque anecdote that Daguerre stumbled on it by accident. He had, so the story goes, put away a number of exposed silver iodide plates in a cupboard which contained various chemicals. Some weeks afterwards he noticed a beautifully detailed image on one of the plates. He exposed fresh plates and put them in the cupboard; after a few hours they, too, became pictures. It seemed as if the cupboard was bewitched. By elimination he discovered that the chemical which had brought out the images was mercury.

The New Partnership: Daguerre and Isidore Niépce

The initiative was now entirely Daguerre's. But although he had replaced Niépce's asphalt process with his silver iodide system, he wanted to continue the partnership with Isidore, and thus, on May 9, 1835, the first paragraph of the original contract was amended to read:

Art. I. There will be a partnership between MM. Daguerre and Isidore Niépce under the business style of Dag. and I——re Niépce for the exploitation of the discovery invented by Daguerre and the late M. Niépce.

Historians have accused Daguerre of highhandedness in this amendment. It was, on the contrary, an act of generosity. Daguerre had worked out a new process virtually alone, squeezing out enough time somehow from his work at the Diorama. If we can judge from the correspondence, Isidore was of no help to him, but insisted upon continuing fruitless experiments with that process of his father's which Daguerre had abandoned.

The earliest daguerreotype in existence is a still life which Daguerre took in his studio (Plate 18). The picture, now in the collection of the French Photographic Society in Paris, is full of detail, with good tonal range. On the back of the frame it bears the date 1837.

In that year, Daguerre drew up a new contract which he asked Isidore to sign. It called for the publication and sale of two separate inventions: Niépce's original

process and the new silver-iodide process which Daguerre claimed as his own. This process, the contract read, "shall carry the name of Daguerre alone, but it can only be made public simultaneously with the first process; in short, the name of M. Joseph Nicéphore Niépce, as is right, must always figure in this invention." The publication of the two inventions would be undertaken by subscription, to be announced in the public press, open from March 15, 1838, to April 15 of the following year. Four hundred subscriptions at 1000 francs each were to be offered. Should a single purchaser of both secrets be found, the sale should be not less than 200,000 francs.

Isidore was furious. To him Daguerre was a disloyal opportunist and a dishonest bully. He refused to sign. He protested that he would seek every means to protect the memory of his father. "You are right," Daguerre replied. "I would have a bad opinion of you if you acted otherwise toward a man whose memory is as dear to me as to you." Daguerre offered an alternative; together they would sell Niépce's still unperfected process; alone he would sell his own. Isidore gave in to him, and signed.

Daguerre's reaction to the attack of his recalcitrant partner was silence. Isidore said that Daguerre never disclosed to him the secret of his process. Their correspondence became confined to business dealings. On April 28, 1838, Daguerre suggested that they drop the plan of selling the invention by subscription: a secret sold to one person is no longer a secret. He thought it better to find an agent or firm to handle the whole business, thus releasing him to work toward perfecting the process, particularly since he had only

six good pictures to show. It was a discouraging letter. At the bottom of it he wrote:

"I have baptized my process thus: DAGUERREOTIPE [sic]."

On January 2, 1839, Daguerre triumphantly wrote his partner: "At last I have seen M. Arago. . . . I entirely approve of M. Arago's idea, which is to have the discovery purchased by the government. . . . M. Arago is going to speak about it next Monday at the Académie des Sciences. . . . I don't think your presence, *cher ami,* is necessary at this time."

"THE ART OF PHOTOGENIC DRAWING"

With Arago as sponsor, Daguerre instantly received the recognition and promised support of the French Government. Talbot, even though he had access to the Royal Society, had no such assurance of official backing. He had been totally surprised by the announcement of the Académie des Sciences, and was forced to make a hasty, premature announcement. ". . . I had no choice; at least, I thought I had none, which comes nearly to the same thing," he later wrote. "But I never supposed for a moment that this memoir [to the Royal Society] would be mistaken for a regular treatise written by me on the Photogenic art. . . . Many points were necessarily omitted, or abridged. . . ."

Talbot Reveals His Process to the Royal Society

The French were unreasonably impatient with Talbot. Although they showed restrained respect for him, because of his eminent position in the world of science, they fairly demanded that he prove by publi-

cation the priority which he claimed. Biot, in the
Comptes rendus of the Académie des Sciences, had
presented a detailed report on a paper process which
Daguerre said he had abandoned in 1826. Biot thought
it was identical to Talbot's. There was no time to lose.

Sir David Brewster urged his friend Talbot to patent
his invention. "I hope you mean to pursue the subject
and endeavour to perfect the process," he wrote Tal-
bot on February 4, 1839, in acknowledging receipt of
The Literary Gazette. "You ought to keep it perfectly
secret till you find you cannot advance further in the
matter, and then it would be advisable to secure your
right by a Patent. Altho' you do not require to deal
with the matter commercially, yet a Patent would give
a more fixed character to your priority as an Inventor,
and I do not see why a Gentleman with an independ-
ent fortune should scruple to accept of any benefit
that he has derived from his own genius."

Talbot did not follow his friend's advice, but in a
paper read at the Royal Society on February 21, 1839,
published his technique without restrictions of any
kind.

His directions were simple: "In order to make what
may be called ordinary photogenic paper, I select, in
the first place, paper of a good firm quality and smooth
surface. I do not know that any answers better than
superfine writing paper. I dip it into a weak solution
of common salt [sodium chloride, NaCl], and wipe it
dry, by which the salt is uniformly distributed through-
out its substance. I then spread a solution of nitrate
of silver [$AgNO_3$] on one surface only, and dry it at
the fire. The solution should not be saturated, but

six or eight times diluted with water. When dry, the paper is fit for use."

By this treatment silver chloride (AgCl) was precipitated in the fibrous substance of the paper:

$$NaCl + AgNO_3 = AgCl\downarrow + NaNO_3$$

Talbot found by accident that his paper on exposure to light turned dark more quickly when he moistened it with a weak solution of salt and then washed it with a strong solution of silver nitrate. "As this circumstance was unexpected," he wrote, "it afforded a simple explanation of the cause why previous inquirers had missed this important result, in their experiments on chloride of silver, namely, because they had always operated with wrong proportions of the salt and silver, using plenty of salt to produce a perfect chloride, whereas what was required (it was now manifest) was, to have a deficiency of salt, in order to produce an imperfect chloride, or (perhaps it should be called) a *subchloride* of silver."

This was a basic discovery, unknown to science. For years it had been thought that all silver chloride, no matter how made, was alike: one atom of silver combines with one atom of chlorine to form one molecule of silver chloride. By the Law of Definite Proportions the exact amount of silver and chlorine needed to form a "perfect" silver chloride is in exact proportion to their atomic weights. Thus 107.9 units by weight of silver, no more, no less, combine with 35.5 units by weight of chlorine to form silver chloride. Chemists at Talbot's time believed that any excess of either silver or chlorine simply remained in solution, and played no part in the formation of the precipitated salt.

A Modern Explanation of Talbot's Discovery

Today we no longer limit our concept of crystalline matter to individual molecules, but to the structure of large numbers of molecules or ions in the crystals. The ions (that is, electrically charged atoms) are held together by mutual electrical attraction in a three-dimensional structure, whose architecture determines in part the physical and chemical characteristics of the crystalline compound. In silver chloride, silver and chlorine have become ions. Each silver atom has transferred to a chlorine atom one electron, thus forming positively charged silver ions (Ag^+) and negatively charged chloride ions (Cl^-). Some of these, their number determined by the Law of Definite Proportions, combine to form a lattice crystal (Fig. 5).

FIGURE 5

Any excess ions seek oppositely charged ions on the faces of the crystal and are adsorbed. Looking down

on one face of a silver chloride crystal made with silver in excess, we see that, ideally, the crystal becomes as a whole positively charged (Fig. 6). Actually not all the Cl⁻ ions are neutralized, but many are.

FIGURE 6

This is the type of silver chloride which Talbot found to be most satisfactory. It turns dark by the direct action of light which causes the transfer of electrons mentioned above to be reversed. Some silver ions gain an electron, and thus become silver atoms:

$$Ag^+ + electron \rightarrow Ag$$

Unless the chlorine atoms (Cl) or molecules (Cl_2) have some place to go, they will recombine with the silver atoms. So there must be acceptors in the system. When, as in Talbot's experiments, paper is the support, some chlorine combines with the cellulose of the paper, or the starch used to size it.

Talbot's Stabilizer

Silver chloride made with chlorine in excess is, ideally, negatively charged (Fig. 7). It is far less sen-

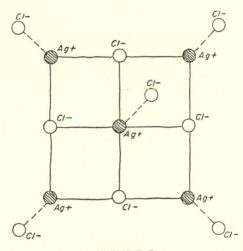

FIGURE 7

sitive to the direct action of light than the positively charged variety. Talbot did not then know that even though light produced little or no visible change, by subsequent chemical treatment the exposed silver halide could be reduced to silver. He used its insensitivity to "fix" his photogenic drawings so that they would not turn dark all over when examined in daylight. He bathed the pictures in a strong solution of sodium chloride. The chloride ions in the solution were adsorbed to the unexposed silver chloride crystals, making them relatively insensitive to the direct action of light. He did not truly "fix" them; in modern terminol-

ogy he "stabilized" them. The problem which had baffled Wedgwood and Davy he solved.

An alternate method of preserving the photographs was to wash the paper with potassium iodide after exposure. This treatment not only converted the residual silver salts to silver iodide, but also stabilized the crystals by adsorption of negative ions, in this case of I^-. Talbot's statement that silver iodide itself was "absolutely unalterable by sunshine" is incorrect; he did not know that the light sensitivity of silver iodide was the basis for Daguerre's process. But from the practical point of view, Talbot's technique rendered his negatives sufficiently stable "to bear sunshine" for periods long enough to allow him to print positives from them by contact.

Talbot sent a précis of this paper, written in French, to Arago at the Académie des Sciences. He concluded (we translate): "My excellent friend, Sir J. Herschel, has recently shown me a very beautiful method he has invented for preserving photogenic pictures. But I ought not to describe it without asking his permission. I will simply say that I have repeated his experiments with full success."

HYPO

Sir John Herschel Resolves to Discover the Secret

Sir John Frederick William Herschel, past president of the Royal Society, and famous as mathematician, chemist, and astronomer, first heard of Daguerre's announcement on January 22, 1839, when he received a note about it from his colleague Captain Francis Beaufort, hydrographer to the Royal Navy and author of the wind velocity scale that still bears his name.

Herschel's intellectual curiosity was at once aroused, and he set about solving the mystery in his laboratory in Slough, a town nineteen miles west of London, near Windsor Castle. His notebook, now preserved in the Science Museum, London, gives us a vivid, firsthand account of how he independently invented a workable photographic system.

On January 29, he wrote at the top of the blank page: "Experiments tried within the last few days since hearing of Daguerre's *secret* & that Fox Talbot has also got something of same kind."

"Experiment 1012 . . . blackening of silver-salts spread on paper." He tried four salts of silver: the chloride, the carbonate, the acetate, and the nitrate. The light-sensitivity of paper washed with these chemicals was tested by exposing "in the leaves of a book ⅓ in ⅔ out."

He noted that the carbonate was the most light sensitive, but it was difficult to coat it on the paper. He concluded that the nitrate was the best. He made a memorandum to try benzoate, ferrocyanate, and fulminate.

Experiment 1013, also made on January 29, was epochal: "Tried hyposulphite of Soda to arrest action of light, by washing away all the Chloride of Silver or other silvering salt.—succeeds perfectly.—paper ½ acted on ½ guarded from light by covering with pasteboard were when withdrawn from sunshine sprayed over with hyposul. soda then well washed in pure water—dried again exposed.—The darkened ½ remained dark. The white half white after any exposure as if they had been painted with Sepia.—"

Herschel's fixing technique is still standard practice for all photographic processes using the salts of silver. The chemical which he described as "hyposulphite of soda" was one of a group of salts derived from an acid discovered by him in 1819. Today we recognize it to have the formula $Na_2S_2O_3 \cdot 5H_2O$, and its name has been changed to "sodium thiosulfate."* However un-

* The prefix "hypo-" has traditionally been used by chemists to indicate a lower state of oxidation. Herschel named his acid, $H_2S_2O_3$, "hyposulphurous" because he thought that in its oxygen sulfur ratio it was next lower to sulfurous acid. However, in 1861, the French chemist P. Schützenberger discovered the acid $H_2S_2O_4$. It occupies the very position Herschel assigned

academic, we, like every photographer, will use the word "hypo" to indicate this important chemical. Herschel noted that it dissolves silver chloride "in large quantity, and almost as readily as sugar in water."

Actually, hypo does not dissolve silver salts this way. Evaporate a sugar solution and you recover the sugar. But you cannot recover silver chloride from the hypo solution after fixing. The silver halide combines with the sodium thiosulfate ("hypo") to produce a series of complex sodium salts of the argentothiosulfuric acids. The principal reaction is

$$AgCl + Na_2S_2O_3 = NaCl + NaAgS_2O_3$$

Other double salts are produced as fixing proceeds. Most of these salts are soluble in water, and consequently can be washed away. Thus, by the use of hypo, the unused silver chloride is removed, and the image, no longer bearing any light-sensitive compounds, becomes permanent.

Herschel, on the day after noting his successful experiment in fixing with hypo, wrote in his laboratory notebook: "Formed image of telescope with the aplanatic lens . . . placed in focus paper with Carb Silver. An image was formed in *White* on a sepia-col[d] ground after about 2 hours exposure which bore washing with

to his acid, so a change in nomenclature became necessary. By subtracting the elements of water from the various acids the progression becomes:

Sulfuric acid	$H_2SO_4 - H_2O = SO_3$
Sulfurous acid	$H_2SO_3 - H_2O = SO_2$
Schützenberger's acid (now called hyposulfurous)	$H_2S_2O_4 - H_2O = S_2O_3$
Herschel's acid (now called thiosulfuric)	$H_2S_2O_3 - H_2O = S_2O_2$

the hypos. Sod. & was then no longer alterable by light. —Mons Daguerre's process is so far solved."

He now tried making contact prints from engravings, oiling them to make them transparent (as Niépce and Talbot before him had done), placing them face down on his silver carbonate paper, and exposing them to light. He noted that the result was an image with the tones reversed: black was white and white was black. On the following day he noted: "Tried a rereversal. It succeeded—but not well but there can be no doubt about it when all the Minutiae are learned."

Herschel Suggests the Use of Hypo to Talbot

On Friday, February 1, Talbot came to Slough. Herschel showed him "an Engraving (a lithographed subject) just transferred in Carb. Silver & washed with hypos. sod. also a picture of the telescope just fresh formed.—Explained to him all my processes."

Talbot was less generous. Herschel noted that Talbot "also shewed me his specimen of results but did not explain his process of what he called 'fixing'—by way of trial of the power of my process of 'washing out' he gave me one of his unfixed specimens. In 2 minutes I brought him half of it washed the other not and on exposing both the washed half was unchanged the other speedily obliterated & at length grew quite dark."

Soon after this visit, Herschel gave Talbot permission to publish his use of hypo. "I rather wish it to be known," he wrote Talbot, "and have myself now mentioned it *conversationally* to more than one inquisitive person though I have no idea of writing on the sub-

ject unless something should come up of a more strik-
ing character than anything I have yet hit upon." But
Talbot evidently decided against publication, for on
February 12 Herschel wrote him: "I shall mention no
further the process of washing out with Hyposulphite
if you disapprove of it & shall wait with patience for
the revelation of your mode of fixing which must be
a very chemical bijou." Herschel suggested collabora-
tion: ". . . on comparing notes a process may arise
better than either would have divised [sic] separately."
But nothing came of this proposal: Talbot went his
own way and Herschel generously stepped aside. He
published none of his research until after Talbot had
disclosed his process.

"Photography"

To describe his work Herschel used a new word:
Photography. On the back of a print of his telescope
he wrote "J. F. W. H. photogr. 10 Feb. 1839." Three
days later he noted: "Fine and sunny day. At work all
day with great interest and success at Photography and
chemical rays. Discovered Talbot's secret, or one
equivalent to it. It is the Ferrocyanate of potash. It
fixes the optical image. . . ."

Herschel's guess, as we know, was wrong. But the
experiments proved fruitful, for he observed that treat-
ment with "ferrocyanate of potash" (potassium ferro-
cyanide) gave a blue color, and this observation led
him to investigate the action of light on compounds
of iron. The best known of the processes that came out
of this research is the *blueprint,* which he named
"cyanotype." Light reduces ferric salts to ferrous salts;

these react to form ferrous ferricyanide, an insoluble compound known as Turnbull's blue. In today's practice a sensitizing solution is made of potassium ferricyanide and ferric ammonium citrate. This is simply brushed on sized paper and allowed to dry. The paper is too slow for use in the camera: it is exposed beneath a drawing or a negative to sunlight or intense artificial light. A faint greenish image is formed which becomes intense blue when it is washed in water. No fixing is required, as the unexposed iron salts are soluble, and are washed away.

By the end of February, Talbot reversed his opinion of hypo, and asked Herschel for permission to communicate this fixing process to the French. Herschel obliged his friend at once, and sent samples to accompany the report. In the letter he used the word "photographed," and explained that he preferred it to Talbot's word "photogenic," which, he said, "recalls Van Mons' exploded theories of thermogen and photogen. It also lends itself to no inflexions and is out of analogy with Litho and Chalcography."

Talbot then wrote Biot, who read extracts from the letter to the Academicians. There were, Talbot reported, two other chemicals in addition to sodium chloride and potassium iodide that could be used to fix photogenic drawings. The third was potassium ferrocyanide—but this was unreliable and not recommended. "The fourth method, which is worth all the others combined, is to wash the drawing with hyposulphite of soda. This process came quite naturally to Mr. Herschel's mind, because he himself discovered hyposulphurous acid, and defined its principal properties, among which he found especially worthy of notice that

the hyposulphite of soda readily dissolves silver chloride (a substance ordinarily only slightly soluble). . . . This method of preserving the drawings differs essentially from the three others in that the silver salt is not *fixed* or *rendered insensitive* in the white parts of the drawing, but is completely *removed.*"

Thus the honor of publishing Herschel's invention fell to the French.

Daguerre at once adopted it.

CONTENDERS FROM ALL SIDES

Bauer Defends Niépce

The news of the French Government's announcement of Daguerre's invention and the Royal Society's endorsement of Talbot's photogenic technique was both puzzling and disturbing to Francis Bauer, the botanist in Kew who had befriended Nicéphore Niépce in 1827 on his brief, frustrating trip to England. He knew, better than anyone else in England, the contribution which Niépce had made. He owned four of his original heliographs and a manuscript copy of the very memoir which Niépce tried so desperately to bring before the Royal Society. He was puzzled that the only mention of his French friend's work was the quotation in *The Literary Gazette* of Arago's casual note: "M. D[aguerre] generously owns that the first idea of his process was given him, fifteen years ago, by M. Nieps [sic] of Chalons-sur-Saône [sic], but in so imperfect a state, that it has cost him long and preserving labour to attain the object.''

Bauer, who had lost touch with his friend, and had no knowledge that he had become Daguerre's partner, was grieved to learn that Niépce was dead. He felt so strongly that an injustice had been done to his late friend that he wrote a letter to the editor of *The Literary Gazette,* which appeared in the March 2, 1839, issue. He was indignant: "Now I do not think M. Niepce could have given such a very imperfect idea fifteen years ago, as the specimens M. Niepce brought and exhibited in 1827 *in England* (and some are still in my possession) are quite as perfect as those productions of M. Daguerre described in the French newspapers of 1839." (Bauer's loyalty surpassed his sense of judgment: Daguerre's work had not been seen in England when he wrote.) He went on to say that although he had not seen Talbot's work, it, too, must be grounded on Niépce's process. He appended to the letter a translation of Niépce's memoir, and he offered to show the heliographs to any "scientific gentleman or artist to whom this subject might be interesting."

Talbot accepted the invitation. On March 7, he wrote Bauer: "Having observed in the Literary Gazette of last Saturday that you say, you have not yet seen any of my photogenic drawings, I will do myself the pleasure of calling on you on Saturday next, in company with my friend Professor Wheatstone, & I will bring some of the specimens with me."

Sir Charles Wheatstone (he was knighted in 1868 in recognition of his research in electricity) was already briefed by Bauer. He offered to present the heliographs at the Royal Society meeting of March 14. But he changed his mind: "Our new president the

Marquess of Northampton has announced his first soirée for Saturday the 9th of March," he wrote Bauer, "and I think this would be a better opportunity of introducing your late friend's invention to the scientific world."

The president's first conversazione, as these frequently repeated soirées came to be called, was a social as well as scientific success. *The Athenaeum* noted that "the style of the entertainment was rather more sumptuous than has been usual, or is indeed desirable, at these scientific meetings, but all present had reason to be well satisfied with the courteous and personal kindness of the President." Pictures by Talbot and Herschel were shown, as well as Niépce's heliographs. Bauer wrote Isidore Niépce that the informal exhibition of his father's pioneer work was highly successful. The guests included not only members of the Royal Society but also "scientists, artists and the nobility who were staying in London in this season. I showed the four drawings, or trials, made in heliography by your father, with the autograph memoir he wrote himself. In view of the fact that nobody present had the least knowledge of that art, of which the very idea is ignored in England, this exhibition brought forth the liveliest sensation in that meeting, and it was unanimously acknowledged, and it was even declared, that Daguerre was but an usurper to be ridiculed, and I really have reason to believe that in England this name will never be given to this art."

This defense of his father greatly moved Isidore Niépce. He wrote Bauer: "Providence, whose justice cannot long be overlooked, made your compatriot Talbot appear to us; the question of priority raised,

it had to be answered; my father's name could protect Daguerre and it became indispensable to bring it forth from the oblivion in which it had been plunged; his work had covered a period of twenty-five years, it had to be proven; the articles of partnership existed, they had to be brought to light; in fine it had to be shown that he was the only, the real inventor of a discovery which brought universal admiration; thus my father's name reappeared like the sun after a thick fog! From this moment I am happy, satisfied; my goal is reached, and from the bottom of my heart I thank Mr. Talbot, who can hardly realize the important service he had rendered me!"

Talbot Sensitizes Paper with Silver Bromide

Talbot was more interested in improving his own invention than supporting another's. He found that he could increase the sensitivity of his paper by substituting silver bromide for silver chloride. He described his technique in a letter, dated March 15, to Biot of the Académie des Sciences and in a memorandum, on March 21, to the Royal Society. "Take good writing paper, and wash it over with nitrate of silver; then with bromide of potassium; and afterwards again with nitrate of silver; drying it at the fire between each operation." Thus Talbot produced silver bromide with silver greatly in excess. By our standards the light sensitivity of his silver bromide paper was extremely low. "From want of an acknowledged unit of measure," Talbot wrote, "it is difficult to define its *degree* of sensibility; but the following experiments made during the bad weather of last week, will serve as an approxima-

tion. At five P. M. in very cloudy weather, in London, this paper being placed in a camera obscura and directed towards a window, a picture of the window bars was obtained in six minutes."

Photogenic Pictures from Glass

Talbot also explained to the Royal Society how he made prints from drawings on glass plates. "Take a sheet of glass and smear it over with a solution of resin in turpentine; when half dry, hold it over the smoke of a candle; the smoke will be absorbed by the resin, and although the glass will be darkened as usual, there will be a sort of glaze over the smoke which will prevent it from rubbing off. Of course, if any opaque varnish should be at hand, it will be simpler to use that. On this blackened surface, when not quite dry, let any design whatever be made with a needle's point, the lines of which will, of course, be transparent. When this is placed over a sheet of prepared paper, a very perfect copy is obtained; every line which the needle has traced being represented by a dark line upon the paper. In the autumn of 1834, being then at Geneva, I tried several *photogenic etchings* in this way, which were executed for me by a friend, as I am not skilled in drawing. . . . Another application of the same principle, is to make copies of any writing. This is so very easy, and each copy takes so short a time in making, that I think it may prove very useful to persons who wish to circulate a few copies among their friends of anything which they have written; more especially since, if they can draw, they may intersperse their text

with drawings, which shall have almost as good an effect as some engravings."

Talbot apologized for presenting this technique as if it were an afterthought. He said that his first account of photogenic drawing was written in great haste, "in the course of a few days." Consequently much was omitted, including this reprographic technique which, years later was called *clichés-verre,* and was used by the painters Corot, Millet, Daubigny, and others for some of their finest graphic work. There was a pressing reason for stating this claim, even belatedly, for examples of this very process were shown by Faraday at the Royal Institution on March 22. They were made by William Havell and James Tibbits Willmore, both engravers, who proposed to join with other artists to secure a patent for this alleged invention.

Willmore was incensed that Talbot claimed this process as his own. He wrote the editor of *The Literary Gazette,* on April 2:

"If it be the subject of reproach that a man, having made a discovery which he believes to be valuable, attempts to secure a personal benefit by a patent, it will apply to hundreds of inventions for which patents have been obtained. I did, certainly, with two other artists, attempt to secure one for the particular application of this new art; and I believe that it would have been tenable, but for some melancholy circumstances which led to the disclosure, and its abandonment. . . . Why Mr. Talbot should have felt sore, and jealous . . . I cannot understand. . . ."

Talbot answered: "I have the greatest dislike to controversy, which I regard as a complete waste of time. I consider it sufficient to have stated, once for

all, in your widely circulated journal, that I discovered the art of obtaining photogenic pictures *from glass* in the year 1834. . . . It would have been sufficient for me to refer to the seventh section of my first memoir to the Royal Society (published January 31). But, since that account seemed to have been already in some measure forgotten by the public, I stated it again, and in a fuller manner. How could I do otherwise, when I found that a patent had been applied for for this identical process?"

Beneath Talbot's letter the editor printed a note from Willmore's former partner, William Havell. He stated that he had dissociated himself from those who planned to apply for a patent: "I beg to explain, that I knew nothing of their proceedings till after the attempt had been made, and I then expressed my decided disapprobation and opposition to the whole affair."

Nothing further was heard from Willmore; the matter was completely dropped. But the patent issue was to have reverberations throughout the whole photographic world. Talbot could hardly have acted otherwise, for he would have lost the very principle of his invention if an application of it was patented. The incident raised the question: Can such an invention as photography be patented? Arago thought not. Sir David Brewster thought yes, and had already advised Talbot to file an application. Talbot took the attitude that he should publish his process for the public good, with no strings attached, and with no thought of personal gain.

Projection Printing

In his rebuttal of Havell's claims, Talbot spoke of yet another application of his invention: "the power of extending or diminishing a design in any required ratio"—the process which became known as enlarging or, more properly, projection printing. All that would be required, Talbot said, was an optical system to project on sensitized paper an image of the required size. Herschel already had accomplished this projection, and Talbot quoted from a letter the astronomer had written him on March 27, 1839: "By placing an etching on a *smoked* glass (not having a resinous ground) behind an *aplanatic* lens, the smoked side towards the focus, a copy of the etching *reduced* on any required scale, is obtained. By exposure to a solar beam radiating from the focus of a lens, the scale may be enlarged. The reducing process, on trial, succeeded perfectly, only a little care is required to follow the sun. By the use of highly sensitive paper, this inconvenience would be diminished; and, by attaching the whole apparatus to an equatorial with a clock, it would be entirely removed."

Thus, to Herschel's many other discoveries must be added that of projection printing, which was to become a classic procedure in photographic technology. A score of years after Herschel's suggestion, batteries of "solar cameras" were to be seen on the roofs of photographic galleries, each containing a glass negative and a piece of sensitive paper. Apprentices aimed these giant enlargers at the sun for hours at a time, so massive was the required exposure.

Herschel's Research in Photochemistry

Herschel was the most industrious, ingenious, and inquisitive of the early experimenters. His goal was neither the invention nor the perfection of a practical photographic process but the understanding of the changes produced by light on all manner of substances, both organic and inorganic. In a word, the subject of his extensive research was photochemistry.

His first report to the Royal Society—a "Note on the Art of Photography"—was read at the March 14, 1839, meeting. It never appeared in print, for it was withdrawn by Herschel and only a brief abstract of it was printed in the Society's *Proceedings*. Herschel never explained his reason for this unusual action, but it is clear that he did so out of respect to Talbot, for when he did publish his experiments in the following year he took special pains to give full credit to Talbot whenever possible. He announced that he had "purposely abstained from repeating Mr. Talbot's experiment . . . being desirous of seeing what progress I could make in the inquiry without external aid." And he felt himself "obliged to admit" that Talbot's paper far exceeded anything he had "yet produced of a manageable kind."

Herschel, in his first report, described fixing with hypo, the making of copies, the curious phenomenon that the light sensitivity of photographic paper increases when exposed in intimate contact with glass, and the response of photographic paper to the various colors of the spectrum. His generous gesture to Talbot in withholding publication was made at the very moment when contenders from all sides were vigorously claiming priority and were publishing photographic

techniques which emulated, if they did not imitate, Talbot's.

Reade's Alleged Discovery of Photography in 1837

The Reverend Mr. Joseph Bancroft Reade, Vicar of Stone, Buckinghamshire, laid claims to having invented a photographic process as early as 1837. He was more scientist than cleric; he seems to have looked upon his ecclesiastical position as a living, and microscopy as a career. His work in this field won him a Fellowship in the Royal Society, and the annals of microscopy record that he designed an improved solar microscope. This now obsolete instrument differed from the conventional microscope in that the image was not viewed through an eyepiece, but was projected on a screen in a darkened room. The sun's rays, reflected by a mirror, furnished the illumination; hence the name "solar microscope."

Reade was bothered because he did not have sufficient skill to make drawings of the enlarged images thus thrown on the screen, and had to rely on the artistic talent of a friend, Lens Aldous, for these essential records of his observations. Logically, he turned to a photographic process. We know, from a recently discovered letter, that he met with success in 1839, when he wrote to his brother George on April 1: "You will perhaps be surprized to hear, that the exquisite images of microscopic objects which I produce by means of my solar microscope can now be fixed permanently on the paper wh received them by a certain chemical process. I discovered it on Tuesday last at 12 o'clock and I had but one hour of sunshine to put my process to the test. . . . It is probable that you know that this art of Photo-

genic Drawing has made some stir in London, and all that I lay claim to is the discovery of a prepared paper sufficiently sensitive to be readily acted upon after it has been greatly attenuated by passing thro' a double French combination Achromats with an angle of aperture just more than 20°. . . ."

A few days later, he described his process to Edward William Brayley, a scientist who planned to lecture on it. He washed writing paper with silver nitrate and allowed it to dry in the dark. Just before use he brushed it with an infusion of nut galls, that is, gallic acid. After exposure of five minutes or more, he fixed the image with sodium thiosulfate. Reade makes no mention of experiments made prior to Talbot's disclosure of his process: indeed he takes the Photogenic Drawing process for granted, and specifically laid claims only for its perfection.

Reade exhibited photomicrographs of a flea, a section of cane, and the spiral vessel of rhubarb on April 27, at a conversazione held by the Marquess of Northampton, the president of the Royal Society, in his London mansion. He said that he introduced himself to Talbot, "who made some inquiries to ascertain in certain pictures exhibited, how much of the process was due to the artist." Reade explained his technique to Talbot. Although Talbot later stated that he had no recollection of this meeting, in his notebook entry for April 5, 1839, he wrote: "Dilute gallic acid, and dilute nit. silver mixed turn dark in daylight (I believe Mr. Reade discovered this.)"

Subsequently Talbot was to base the new system of photography which he patented in 1841 upon the use of gallic acid. His right to renew this patent was challenged in court in 1854, and Reade, when called to testify, declared that he obtained his first picture by

infusion of galls in 1837. This claim for priority is questionable, in view of the letter Reade wrote to his brother in 1839. But the light sensitivity of silver nitrate treated with gallic acid was unquestionably his discovery, and was to prove revolutionary in Talbot's hands.

Hercules Florence Reports from Brazil

Hercules Florence, a Frenchman living in Brazil, claimed that as early as 1832 he made photographs with a camera and by contact printing. His notebooks between 1833 and 1837 contain clear descriptions of his technique and, even more remarkable, the word "photographie"—two years before Herschel suggested it to Talbot. Contact prints of a diploma and labels for pharmaceutical bottles made by Florence exist, though none of his camera work appears to have survived. One hearing the news from Paris of Daguerre's process, Florence modestly wrote: "Perhaps it is too bold for me to say that I, too, invented photography, a name which was not new to me when I saw it for the first time in the paper from Rio de Janiero; but the truth is that I did not continue with my experiments, and for this reason I do not want to claim as my own a discovery that someone else may have a better right to."

The list of contenders for the honor of inventing photography is yet longer. The very number shows how widespread and sporadic invention commonly is. Over and over again in the annals of inventions of all sorts—the electric light, for example, the telegraph, the motion-picture projector, the automobile, the airplane—we find that the same idea occurs to many individuals, unknown to one another, and often living at opposite points of the earth.

A SPATE OF EXPERIMENTS

The news of the independent discoveries of Daguerre and Talbot "turned the brains of half the world," to quote the Parisian correspondent of *The Athenaeum*.

Draper's "Luminous Rays"

In America, the news of Talbot's publication reminded Professor John William Draper of New York University that, back in 1834, he had published in the *Journal* of the Franklin Institute a technique for "determining the effect of absorbent media on the luminous, calorific, and chemical rays" of the sun and, like Reade, was inspired by Herschel to use hypo for fixing silver halide images. He devised apparatus which would project two spectra in a darkened room. One spectrum passed through a glass cell, filled with a colored fluid, such as an orange solution of potassium bichromate. The other spectrum was unimpeded. He found that part of the spectrum was absorbed by the colored fluid. By comparing the complete spectrum

with the incomplete one beside it, he could note what "luminous rays" were absorbed. By collecting each spectrum with a lens focused on one of the bulbs of a differential thermometer he could measure the strength of the "calorific rays" which were absorbed. And by allowing the two spectra to fall on the same piece of paper coated with silver chloride or silver bromide he could measure what "chemical rays" were absorbed by noting the darkening of the sensitized paper.

Draper found that the spectrum when filtered through orange had no effect on the silver bromide paper, but when filtered through blue it had a strong effect. He later claimed ". . . the bromuretted paper enabled me, at that early period, when the attention of no other chemist was as yet turned to these matters, to trace the blackening action from far beyond the confines of the violet, down almost to the other end of the spectrum."

Color Sensitivity of Silver Halides

He was apparently unaware that the sensitivity of silver halides to various wavelengths had been the subject of much prior research. Carl Wilhelm Scheele, in 1777, observed that violet rays affect silver halides more strongly than the other rays. Jean Senebier tabulated, in 1782, the relative darkening powers of the visible spectrum: he found that if fifteen seconds were required for the sensitized paper to reach its maximum blackening under violet light, a twenty-*minute* exposure was required under red light.

These experiments were not photographic but pho-

tochemical. Scheele and Senebier were not concerned
with recording an optical image. But—to believe his
recollections—Draper applied what he had learned
from his photochemical experiments to picture-
making.

He tried to record camera images with silver-
sensitized paper long before 1839. "The difficulty at
this time," he recollected in 1858, "was to fix the im-
pressions. I had long known what had been done in
the copying of objects by Wedgwood and Davy, had
amused myself with repeating some of their experi-
ments, and had even unsuccessfully tried the use of
hyposulphite of soda, having learnt its properties in
relation to the chloride of silver from Herschel's ex-
periments, but abandoned it because I found it re-
moved the black as well as the white parts. This want
of success was probably owing to my having used too
strong a solution, and kept the paper in it too long."

When Talbot's directions for making photogenic
drawings arrived in America, Draper at once made
some, and tried to take a portrait with a camera which
had a concave mirror instead of a lens. He put sensi-
tive paper "the size of a cent" in the focus of the mir-
ror, and recorded the image of a person standing
against a window. "But then," he wrote, "it was a sil-
houette, and not a portrait. . . ." Later Draper was
to master the daguerreotype process, and his investi-
gation of that silver/silver-iodide/mercury system was
remarkably prophetic of modern theories based on
solid-state physics.

Direct Positives

Yet another photographic technique based on Talbot's process made its appearance almost simultaneously in France, England, and Scotland. If a piece of paper, sensitized according to Talbot's instructions, is exposed naked to light until it is blackened all over and then is washed with potassium iodide, it bleaches on a second exposure to light. Thus direct positives are produced, and the process is analogous to the daguerreotype. The first exposure creates a uniform surface of metallic silver. The application of potassium iodide converts the silver to light-sensitive silver iodide. If the second exposure is of sufficient length, the reversal phenomenon which Daguerre noted in 1831 occurs.

The first publication of this direct positive, or reversal, process was given by the French chemist Jean Louis Lassaigne in the *Comptes rendus* of the Académie des Sciences for April 8, 1839. A similar process was described to the Society of Arts, Edinburgh, by its vice president, Andrew Fyfe, on April 17. Both Lassaigne and Fyfe limited this bleach-out process to copy drawings by contact printing; there is no evidence that either scientist used it in a camera.

But an employee of the French Ministry of Finance in Paris, Hippolyte Bayard, whose interest in photography was that of an amateur, had already used a similar process for making pictures with a camera. On February 5—after Talbot's process was announced but before his publication of it—Bayard made paper negatives. By March 20, he had worked out a direct posi-

tive technique, samples of which he showed to Biot and Arago in May. He kept his process a secret. In June, he exhibited thirty photographs at a charity exhibition for the victims of an earthquake. He was indignant that the Académie would not recognize his work beyond recommending a grant of 600 francs for the purchase of a new camera.

Although most historians have championed the luckless inventor, Bayard's contribution was so entirely personal that it had no effect whatsoever on the subsequent development of photography. He refused to divulge his secret until 1840—and then it was found to be identical in principle to the already published and already obsolete techniques of Lassaigne and Fyfe.

Reflex Printing

In Belgium, Albert Breyer discovered in 1839 that copies of drawings and printed pages could be made by *reflex printing,* that is, by putting the coated side of Talbot's photogenic paper in contact with the sheet to be reproduced, and exposing through the *back* of the paper. Some of the light passing through the sensitized paper is absorbed by the black, inked, areas; its power is lost, and has no effect on the silver halide. On the other hand, some of the light passing through the sensitized paper is reflected by the white areas of the original back to the silver halide coating, which then becomes black. The result is a negative. This method of copying makes it possible to reproduce without a camera one side of a page that has been printed on both sides. The principle is widely used today for reprographic techniques.

Paper Sensitized with Potassium Bichromate

In Scotland experiments were also done, in the frantic spring months of 1839, with non-silver photographic systems. The Scotsman Mungo Ponton made a discovery, hardly noticed at the time, that proved to be of great importance. Potassium bichromate, in contact with an organic substance, has the property of changing its solubility in water according to its exposure to light. Ponton coated paper with a solution of this chemical. The exposed areas turned brown, and became insoluble. The unexposed areas were simply washed away with water. Ponton proposed this process as much for its economy as for its simplicity; neither silver nitrate nor hypo, both expensive, was required. Unfortunately, the paper was not sensitive enough to be used in a camera, and the process did not at first become popular. Later, Talbot was to improve Ponton's process by mixing potassium bichromate with a colloid, such as gelatin. This discovery opened the way for a variety of graphic art techniques, and is fundamental in the photogravure process.

In Italy, there was a flurry of excitement when the *Gazetta di Firenze* reported, on April 2, that there was a seventeenth-century book in the Vatican Library with an extraordinary title which, literally translated, reads: *Description of a New Method of Transposing Any Figure Whatsoever Drawn on Paper By Means of Reflected Solar Rays on Another Piece of Paper by Anybody, Even Though He Does Not Know How to Draw; Invented by Signor Marco Antonio Cellio, and Demonstrated at the Roman Accademia*

Fisico-Matematica Meeting of August 4, 1686. For a
brief moment it seemed that Italy might claim the
honor of having discovered photography—until the
booklet was read and proved to be the description of
an ingenious adaptation of a camera obscura. The
device threw on an easel the optical image of a draw-
ing to any desired size, which then could be traced by
a draftsman. Cellio's book may well give the first de-
scription of the optical device known as an episcope,
or opaque projector.

Talbot's Experiment Reported in Europe

In Germany, the Bavarian Akademie der Wissen-
schaft acknowledged, on March 9, the receipt of Tal-
bot's first Royal Society paper, "Some Account of the
Art of Photogenic Drawing." But since in this com-
munication Talbot did not disclose his technique, the
Akademie decided not to publish it. Two members,
however, Carl August von Steinheil, professor of phys-
ics and mathematics at the University of Munich, and
his colleague, Franz von Kobell, professor of miner-
alogy, at once made experiments, and succeeded in
duplicating Talbot's still-secret technique. The report
in the official publication of the Bavarian Akademie
states that they used "kaustisches Ammoniak" (am-
monium hydroxide) or "unterschwefligsaures Kali"
(potassium thiosulfate) to dissolve the unexposed sil-
ver halides. With their sensitized paper they made a
number of small negatives of buildings in Munich.
These photographs, the first to be made in Germany,
are now preserved in the Deutsches Museum, Munich.

The editor of *The Athenaeum* commented on April

6, 1839: "We may observe that some of our contem-
poraries continue to argue respecting the discoveries
of Mr. Fox Talbot and M. Daguerre, as if a doubt yet
existed as to priority. There can be no doubt on the
subject. Mr. Talbot himself states that for four or five
years his attention has been directed to the subject;
whereas there is abundant proof that M. Daguerre had
made great progress in his discovery—had indeed pro-
duced many drawings, more than a dozen years since.
But we repeat, that the processes are entirely differ-
ent, and the results different; and having seen speci-
mens of all, including among the best of those of Mr.
Talbot, Sir John Herschel, and Mr. Havell, we dis-
tinctly state that those of M. Daguerre far excel any
which have been produced in this country."

English Scientists Examine Daguerreotypes

Arago invited a group of English scientists to in-
spect, in Paris, Daguerre's daguerreotypes. Among
those who accepted were three of Talbot's colleagues
in the Royal Society: Sir John Robison, secretary and
a Fellow of the Royal Society of Edinburgh, James
David Forbes, already famous at thirty for his re-
searches on heat, and Sir John Herschel.

All three were amazed with what they saw.

Robison wrote in *The Athenaeum:* "It was manifest
at once, that M. Daguerre's method of producing pic-
tures was altogether different from anything I had seen
or heard of in England—*the pictures were as perfect as
it is possible for pictures to be without colour,* and
although they did not possess this advantage, its ab-
sence was scarcely felt, as the truth, distinctness, and

fidelity of the minutest details were so exquisite, that colour could have added little to the charm felt in contemplating them; the best idea I can give of the effect produced is, by saying that it is nearly the same as that of views taken by reflection in a black mirror. . . . The smallest crack, a withered leaf, or a little dust, which a telescope only will detect on a distant building, will be found in M. Daguerre's pictures, when sought for with the aid of a high magnifying power."

Forbes wrote his sister: "Of all my Paris reminiscences, by far the most interesting is having seen Daguerre's pictures, a matter which is now of some difficulty; but M. Arago kindly arranged it for a large party of us, the day before I left Paris. I went certainly prepared for a disappointment, yet I have no hesitation in saying I was pleased beyond my most sanguine expectations . . . in short, it baffles belief. All sorts of objects were represented: furniture, plaster casts, curtains, &c., all fixed by the camera obscura; open-air views at different hours of the day fixed in three or four minutes, including the most exquisitely delicate objects, and giving the shadows proper to the time of day in a way no artist can do. . . ." Forbes concluded by quoting, in French, what Herschel said to Arago: "We are only scribblers—you can't imagine. It is wonderful! It is a miracle!" One of the Academicians reported that Herschel said to him, "The trials made in England are child's play compared to Daguerre's. Mr. Talbot himself will soon agree with me for I am going to write him to come and see these marvels."

He wrote Talbot on May 9: "It is hardly saying too much to call them miraculous. Certainly they surpass anything I could have conceived as within the bounds

of reasonable expectation. The most elaborate engraving falls far short of the richness and delicacy of execution, every gradation of light and shade is given with a softness and fidelity which sets all painting at an immeasurable distance. His *times* also are very short—In a bright day 3m. suffices. . . . In short if you have a few days at your disposition I cannot commend you better than to *come and see*. Excuse this ebullition."

There is no record that Talbot took Herschel's advice. He was deeply hurt by his friend's enthusiasm for the success of his rival. Herschel explained: "When I wrote you from Paris I was just warm from the impression of Daguerre's wonderful pictures. After reflexion I feel in no way disposed to abate my admiration. However that has not prevented my wishing that the processes which have paper for their field of display should be perfected, as I do not see how else the multiplication of copies can take place, a branch of the photographic art which Daguerre's processes do not by his own account admit of."

This prophetic letter was dated June 24, 1839, but for some reason was not sent until July 6.

In the interim the French Government was taking action to purchase Daguerre's secret.

DAGUERRE'S TRIUMPH

At every opportunity Daguerre showed his daguerreo-
types to distinguished scientists, artists, and writers.
Among those who came to his studio was the Ameri-
can painter and inventor, Samuel F. B. Morse. He was
in Paris promoting his electrical telegraph, which he
demonstrated at the Académie. Morse was greatly
impressed with the daguerreotypes. "The exquisite
minuteness of the delineation cannot be conceived,"
he wrote his brother. "The impressions of interior
views are Rembrandt perfected."

In return, Morse invited Daguerre to a demonstra-
tion of his telegraph, and, around noon on March 8,
1839, Daguerre climbed the three flights of the apart-
ment Morse shared with the Reverend Mr. Edward
Kirk, on the Rue Neuve des Mathurins. A transmitter
had been set up in one room and a receiver in an-
other. Morse's invention fascinated Daguerre.

It was an unlucky hour for him. Across the city
the Diorama was in flames.

Just before noon, the ticket seller, reporting for

work at the matinee, had smelled smoke. In minutes the theater was on fire. "The flames rose to measureless heights and a devastating rain of red hot coals fell on the surrounding houses." Nothing was saved; in less than half an hour the Diorama was destroyed. Fortunately, Daguerre's apartment on the sixth floor of an adjacent building was not badly damaged, and a portfolio containing notes on his photographic research was saved. But the fire was a crushing blow: Daguerre depended on the Diorama for his living and the financing of his photographic work.

Pensions for Daguerre and Niépce

Arago now redoubled his efforts to obtain a government subsidy for Daguerre and his partner, Isidore Niépce. In the presence of the English visitors, in May, he told Daguerre that he would press the matter. He wrote the Minister of the Interior: "I know personally that M. Daguerre has refused tempting offers made to him at various times in the name of several powerful sovereigns. This fact cannot fail but to add to the importance that all feel toward him. It will increase the already large majority in the Chambers who are waiting for a chance to show their sympathy for the inventor of the photogenic process and the Diorama, who now has had such bad luck.

"I very much hope for an affirmative reply. . . . But supposing that, contrary to my expectation and hope, you think that the government should not take the initiative, I hope you will not think it out of order if, acting according to a desire which has come from every seat in the Chamber of Deputies, I should en-

deavor, by a formal proposition to engage it in the discovery of our ingenious compatriot."

The Minister formed a committee, on June 5, of Arago, Louis Vitet (former inspector of historical monuments and a Deputy from Bolbec), and the painter Paul Delaroche; they were to report "if there is a reason to ask the Chambers for a national recompense" for Daguerre and Niépce. Delaroche was most enthusiastic; he considered the daguerreotype "an immense service rendered to art." Arago was already convinced, and Vitet agreed with him that their answer should be a strong affirmative.

On June 14, the Minister made a confidential proposal to Daguerre and Niépce: if they agreed, a bill would be presented for the approval of the Chambers and the King, stipulating that Daguerre would be paid an annual pension for life of 6000 francs ($1200) in return for the right to publish his daguerreotype process and technical details of the Diorama. Isidore Niépce would receive a pension of 4000 francs ($800) for the right to publish his father's invention. While not princely, the proposed annuities were sufficient for comfortable living by the standards of the day. It cost Nicéphore Niépce 300 francs a month to live in England; he complained that this was excessively high.

So confident were the partners that the proposal would be approved that they at once laid plans for such commercial exploitation of the process as the law would allow. They signed a contract on June 22 with Alphonse Giroux, a relative of Mme. Daguerre, who ran an art shop. Daguerre agreed "to initiate M. Giroux personally into the secret of his invention in all its details" as soon as the bill passed both houses.

Alphonse Giroux et Cie. were given the right to manufacture "the various pieces of equipment which make up the daguerreotype apparatus," and they were "authorized by M. Daguerre to announce that the apparatus is manufactured under his direction." The profits were to be divided; one half to Giroux, one quarter to Daguerre and one quarter to Niépce.

Political action was swift.

The Chamber of Deputies heard the bill on July 9, 1839. Arago spoke in its favor. It was passed on July 9 by a vote of 237 to 3.

The Chamber of Peers heard the bill on July 17. Joseph Louis Gay-Lussac of the Académie des Sciences spoke in its favor. On August 2, it was passed by a vote of 92 to 4.

King Louis Philippe signed the bill on August 7, and it became a law, with docket number 8099.

Daguerre and Niépce were thereupon instructed to make public disclosure of their processes on August 19 at a joint meeting of the Académie des Sciences and the Académie des Beaux-Arts.

Public Disclosure of the Daguerreotype Process

Already there was on the press a seventy-nine-page booklet, *The History and Description of That Process Called the Daguerreotype,* which contained specifications and scale drawings of the camera and processing equipment, and explicit directions for making daguerreotypes. Niépce's original account of the heliograph process was faithfully reprinted, with extensive footnotes by Daguerre so critical and derogatory that they were obviously intended to show up the weakness

of the process that he had abandoned. Arago's report to the Chamber of Deputies was reprinted, with footnotes containing technical details that Arago was then not free to divulge, as well as Gay-Lussac's report to the Chamber of Peers. There is a strange error in the booklet: the date of the presentation of the bill to the Chamber of Deputies is printed "June 15." In fact the proposal was not made until July 3. In their haste, Giroux and Daguerre used the date which had been announced beforehand, but which had to be postponed because of pressure of unanticipated business.

All was in readiness. Monday, August 19, 1839, was a sunny day in Paris, and unusually warm. The auditorium of the handsome Palais de l'Institut, beside the Seine, was stuffy, but by 1 P.M. every seat was taken, even though the meeting was not to begin until 3 P.M. Two hundred people, disappointed that they could not get into the hall, crowded in the semicircular courtyard. There was a strange restlessness.

Arago was the only speaker. He began with an apology: "I have to express my regret that the inventor of this most ingenious apparatus has not himself undertaken to explain all its properties. This morning even I begged—I entreated the able artist to yield to a wish which I well knew was universal; but a sore throat,—fear of not being able to render himself intelligible without the aid of plates—in short a little too much modesty—a burthen that the world bears so lightly —proved obstacles which I have not been fortunate enough to surmount. I hope, then, I shall be pardoned the appearance which I am this day proud to make before this assembly."

There is no verbatim report of what Arago said;

instead the *Comptes rendus* of the Académie des Sciences reprinted his speech to the Chamber of Deputies with extensive footnotes "explaining today what had to be kept secret." Arago gave a detailed history of the discovery of the light sensitivity of silver salts, including the early experiments of Wedgwood and Davy, and the trials of Niépce. He did not mention Talbot at any time. After this lengthy historical introduction he, at long last, and in a somewhat summary fashion, described Daguerre's process. He divided it into five operations:

(1) Polishing and cleaning the silver-plated copper plate,
(2) Sensitizing it with iodine,
(3) Exposing it in the camera,
(4) Rendering apparent the invisible image by the vapor of mercury,
(5) Fixing with hypo, washing with water, and drying.

Arago considered the coating operation to be most critical, "the whole success of the operation depending on the perfect uniformity of the layer of ioduret of silver thus formed." He stated that the eminent chemist Jean Baptiste André Dumas had estimated that the thickness of this silver iodide film "cannot be more than the millionth part of a *millimètre*." Arago despaired at explaining the theory of the process; he "formally declared the positive inability of the combined wisdom of physical, chemical, and optical science, to offer any theory of these delicate and complicated operations, which might be even tolerably rational and satisfactory."

Arago concluded with scientific observations. "It is evident, that the Daguerreotype is an instrument of exquisite sensibility for measuring the different intensities of light, a subject which has hitherto been one of the most difficult problems in Natural Philosophy. It is easy enough to measure the difference in intensity between two lights viewed simultaneously, but when it is desired to compare daylight with a light produced in the night—that of the sun with that of the moon, for example—the results obtained have had no precision. The preparation of M. Daguerre is influenced even by the light of the moon, to which all the preparations hitherto tried were insensible, even when the rays were concentrated by a powerful lens."

The Athenaeum commented: "In physics, M. Arago indicated some of the more immediate applications of the Daguerreotype, independently of those he had already mentioned in Photometry. He instanced some of the most complex phenomena exhibited by the solar spectrum. We know, for example, that the different coloured rays are separated by black transversal lines, indicating the absence of these rays at certain parts; and the question arises whether there are also similar interruptions in the continuity of the chemical rays. M. Arago proposes as a simple solution of this question, to expose one of M. Daguerre's prepared plates to the action of a spectrum; an experiment which would prove whether the action of these rays is continuous or interrupted by blank spaces."

Although this presentation brought "the most enthusiastic cheers" from the listeners, most of them were disappointed. Jules Janin, editor of *L'Artiste,*

an avant-garde art magazine, wrote: "M. Daguerre
would not dare to demonstrate the wonderful inven-
tion he has sold to France. . . . The inventor of the
Daguerreotype has taken refuge in the scholarly and
obliging shadow of M. Arago who, throughout the
whole business, has been his tutor and his godfather.
We expected to see M. Daguerre, his camera, his cop-
per plate, and all the details of this technique, of
which the sun is the chief agent: what we saw was
M. Arago, who came to read a report; we had . . .
the description in place of the demonstration. Now we
do not know of any description, even the most vivid,
the most eloquent, the best possible, even given by
M. Arago, which has the value of the man who says to
you, *'I was there, that is what happened.'* Once we
had recovered from this first momentary disappoint-
ment, we listened attentively and dutifully to M.
Arago's most scientific and quite lucid report, which
won the respect of the scholarly audience for whom
it was written."

The newspaper *Le Figaro* was less tolerant. "Pro-
vided you have learned chemistry and are a distin-
guished technician; provided you know how to study
sufficiently well the atmospheric conditions necessary
to this great work; provided you have mastered phys-
ics, hygrometry, mechanics; then you can produce a
somewhat satisfying sort of gray wash drawing if three
or four members of the Institute are standing by help-
ing you." Arago's precise observations were taken as
directions: "You *clean* the silver plate *with extreme
care,* that is essential, and you expose it to the vapor
of iodine, in such a way that this vapor forms on the

plate a film that is precisely the millionth of a *ligne* [a pre-metric measure approximately $\frac{1}{12}$ in.]. Watch out! Don't go beyond a millionth! Or you'll surely goof!"

The press bristled with similar satire.

THE MIRACULOUS MIRROR

Daguerre's Demonstrations

Daguerre, greatly upset by the hostile reaction of the press, called Jules Janin, the editor who had so strongly expressed his disappointment with the daguerreotype in his magazine *L'Artiste*. "You are wrong," Daguerre told him. "True, my process requires a certain amount of care, but anybody can do it. . . . I'd like to have you come right away to the fourth floor of my house, and before your eyes I'll make a picture as exact, as true, as brilliant, and as beautiful as Raphael himself could ever have made."

Janin and his friends accepted the invitation at once. A lively account of the demonstration appeared in the September 1, 1839, issue of *L'Artiste*.

"We all shouted 'Bravo,' surrounded M. Daguerre, and followed him as excited as children whose father, the colonel, is going to let them fire a rifle for the first time.

"We arrived at Daguerre's and, not without emo-

tion, went into the little room where he works his
marvels. The house is on Boulevard Saint-Martin,
No. 17, beside the Ambigu-Comique Theater. . . .
Daguerre's studio is very simple: on the walls are pretty
engravings, mediocre plaster casts, retorts and beak-
ers. . . . M. Daguerre had already put the box for
the iodine on the table. The mystery was about to
begin.

"Daguerre took a lightly silver-plated copper plate.
He poured some acid on the silver. He wiped it dry,
then rubbed on it a little powdered pumice stone that
he moistened with acid. That done—and it is very
simple—he attached a thin border of the same metal
around the plate with some screws which were in
readiness. The plate was now put on the iodine box.
The iodine is on the bottom of the box and throws its
vapor through gauze upon the mirrored surface of the
plate. The window shades of the room were drawn, it
is true, but the darkness was not so great that we
could not see each other quite well. From time to time
Daguerre took the plate from its box; and not finding
it sufficiently covered with iodine, he put it back in its
place until finally the iodine was spread equally over
the surface, which took on the color of gold. This
operation takes scarcely a quarter of an hour. That
done, you place your colored plate in a kind of wooden
portfolio. The camera awaits you in the next room.
You choose the view you want to reproduce and then
you put in the camera your iodized plate, without
opening the case which protects it. Once in the camera,
the case is opened by a little spring, and soon the
prodigy begins. Light coming from everywhere throws
on the plate all its power and life. The exterior world

is reflected in the miraculous mirror. At this moment
the sun was lightly veiled. 'We'll need six minutes,'
Daguerre said, pulling out his watch. And indeed, at
the end of six minutes he closed the box in which the
plate was contained, and on the plate, all the beautiful
landscape invisible to the eye. Now all he had to do
was to say to this hidden world: *'Show yourself.'* An-
other box was prepared. It contained mercury. By
means of a lamp, this mercury is heated until it reaches
fifty degrees [Centigrade], then little by little, through
a glass put in the box expressly for that purpose, you
see the all-powerful vapor mark each part of the plate
in the appropriate tone. The landscape appears as if
it had been drawn by the invisible pencil of Mab, the
queen of the fairies. When the work is done, you take
out the plate, and put it in hyposulphite; after which
you throw warm water over the plate. The operation
is finished, the drawing is whole, complete, unalter-
able. All that in an hour, more or less. . . .

"Thus this operation, which seemed almost impos-
sible as recounted by M. Arago, is very easy and sim-
ple, as done by Daguerre. So we were right in regret-
ting the other day that Daguerre did not himself
demonstrate to the public who were so impatient, the
new instrument to which he has given his name. . . .

"M. Daguerre wants to make his invention as pop-
ular as possible, and proposes to demonstrate his in-
strument in public, just the way he demonstrated it to
us the day before yesterday. The Minister of the In-
terior, who is honor-bound to propagate this marvel-
ous discovery, for which he has the all-powerful sup-
port of the Chambers, has put at the disposal of
Daguerre the largest room of the immense palace on

the Quai d'Orsay. . . . There M. Daguerre will be beautifully set up and he can easily reproduce the Louvre, the Tuileries palace, the Arc de Triomphe, or the towers of the Cathedral of Notre Dame. Two hundred spectators will be admitted to the lessons of the master, and, without doubt, a single lesson, aided with the brochure that M. Daguerre is publishing, will be enough to make these two hundred spectators as many demonstrators. . . ."

The first public demonstration was on September 3. Daguerre was not a good teacher. "You felt that because of a kind of timidity and embarrassment, common with those not accustomed to public speaking, he was a little curt in his explanations," the reporter for *Le National* commented. "But nonetheless the experiment succeeded, and at the moment when the image was seen it was greeted with a well-merited salvo of applause." Two more demonstrations were held at the Hôtel d'Orsay, and then Daguerre announced that he would meet budding daguerreotypists every Thursday, from 11 A.M. to 3 P.M., at the Conservatoire des Arts et Métiers.

Daguerre's Equipment

The equipment was built by Giroux exactly to Daguerre's specifications. Several of the original 1839 cameras, called (confusingly) "Le Daguerréotype," exist. The one now in the George Eastman House, Rochester, New York (Plate 20), was acquired by Gabriel Cromer, an avid collector of all things pertaining to photography's past. It is an elegant piece of cabinet work. Two telescoping mahogany boxes are

fitted to a common base; the inner box slides backward and forward for focusing. The back of the camera is a frame, containing a ground glass; attached to the bottom by a hinge is a glass mirror in a wooden frame, held at an angle of forty-five degrees by a brass rod. The entire back is removable; after the subject had been composed on the ground glass and brought into focus, the back was taken off and the plateholder put in its place. The plates, which measured $6\frac{1}{2}$ by $8\frac{1}{2}$ inches—a size still known in England as "whole plate"—were fastened to a board with metal buttons. The board fits into a lighttight box with hinged double doors. After the plateholder was put on the back of the camera, the doors, now facing the lens, were opened by pushing semicircular brass arms which protrude through the frame of the plateholder.

The lens, manufactured by Charles Chevalier, was permanently fitted in the front of the camera. It is a two-element, concavo-convex cemented achromat of 38-cm. focal length, 81-mm. diameter, mounted in a brass barrel with the convex side toward the subject. The barrel projects 68 mm. beyond the lens and is closed with a cap pierced by a hole 27 mm. in diameter, serving as a diaphragm. The design of the lens is identical to the one Daguerre described to Niépce in 1832.

In addition to the camera, four wooden boxes complete the daguerreotype apparatus:

1. The iodizing or coating box. This is cubical on the outside, an inverted pyramid on the inside. Particles of iodine were put in a turned wooden cup which was placed on the bottom of the box. Above the iodine is a screen of fine mesh cloth, its purpose to dis-

perse the idoine fumes uniformly over the plate, which rested silver side down on the top of the box, beneath the cover.

2. The mercury bath (as it came to be called). This is of elegant design: four slender legs support a wooden body. The exposed plate, silver side down, was supported at forty-five degrees over an iron pot built in the bottom of the box. An alcohol lamp was put beneath it. A thermometer, its bulb in the mercury and its scale attached to the side of the box, enabled the operator to check the temperature of the bath. The yellow glass window, through which Jules Janin saw the "all-powerful vapors mark each part of the plate," is covered by a double flap.

3. The box for storing chemicals, neatly fitted with partitions to hold bottles of pumice, iodine, alcohol, acid, mercury, and hypo.

4. A box for storing the plates, end opening, with slots to hold twenty-four plates.

The entire outfit cost 400 francs ($80 in the exchange of the day). Parisians complained of the expense, the bulk, and the weight of the outfit. It was not at all the portable instrument they had imagined.

Anybody, of course, could have built the identical cameras and processing equipment from the scale drawings in Daguerre's brochure. So, to protect in some measure their interests, Giroux fastened on each of his cameras an oval label, which reads (in translation): "No camera is guaranteed unless it bears the signature of M. Daguerre and the seal of M. Giroux."

Reactions to Daguerre's Process

Scientists found Daguerre's process a puzzle. Arago said: "Thousands of beautiful daguerreotypes will probably be made before its mode of action has been completely analyzed." Talbot received Daguerre's manual in Birmingham, where he was attending a meeting of Section A of the British Association for the Advancement of Science. He recalled: "I took the opportunity to lay before the section the facts which I had myself ascertained in *metallic photography.* . . . In the year 1834 I discovered the method of rendering a silver plate sensitive to light by exposing it to iodine vapours. I was at that time, therefore, treading in the steps of Daguerre, without knowing that he, or indeed that any other person, was pursuing, or had even commenced or thought of, the art which we now term Photography.

"But as I was not aware of the power of mercurial vapour to bring out the latent impression, I found my plates of iodized silver deficient in sensibility, and therefore continued to use in preference my *photogenic drawing paper.*"

He noted Arago's despair at explaining "this delicate and complicated process." If after six months' experience the distinguished French scientist was baffled, "it seemed as if a call were made on all the cultivators of science to use their united endeavours, by the accumulation of new facts and arguments, to penetrate into the real nature of these phenomena."

Already Jean Baptiste Biot had made the profound observation that more than *light* was involved in the

phenomenon of photography, for the material was sensitive to invisible, as well as visible, radiation. He set forth, in the *Journal des Savants,* March and April 1839, a remarkable prophecy: that Daguerre's discovery would provide scientists with a tool for the study of radiation, about which, he said, "we know nothing." And he went on: "The elements of general radiation that can thus be identified and analyzed are the agents which excite—perhaps even which determine—an infinite number of reactions of living organisms, and the very impressions which they experience. For example: the sensation of light, of heat, superficial secretion, and absorption, probably still many other functions that we know nothing about, because we lack the physical means of studying or making them manifest. Who knows if radiation of all kinds—igneous, celestial, terrestial—are of the same nature, or if they have specific properties which influence inorganic and organic bodies differently?"

Later in the year, Alphonse Donné proposed a theory to explain the mechanics of the daguerreotype. He observed that silver iodide formed by the coating or sensitizing operation, adhered to the plate with considerable tenacity. But after exposure the silver iodide became exceedingly fragile, and could easily be rubbed off. He thought that light exerted a physical action, and imagined that the exposed silver iodide was disintegrated, leaving microscopic holes through which the mercury could reach the silver plate and there form the amalgam. The unexposed silver iodide, firmly attached to the plate, acted as a mask.

John William Draper, who was one of the first in America to repeat Daguerre's experiments, thought

that the process was related to what he called "the polar decomposition of water"; that is, electrolysis. "We know that no iodine is ever evolved from the plate, even under the most prolonged action of the light. The cause of the final appearance of the image is due to silver being liberated on the anterior surface of the plate. . . . From the circumstance, therefore, that iodine is evolved at the back of the film and silver at its front, and the film itself remaining the same in thickness throughout, it is obvious that there is a strong resemblance between this phaenomenon and that of the polar decomposition of water. The electropositive and electro-negative elements are yielded up on opposite faces of the film, and its interior undergoes incessant polar changes—the oppositely electric particles sliding, as it were on one another." This theory is remarkably compatible with modern explanations of photolysis based on solid-state theory.

INTERNATIONAL SUCCESS

The Word Spreads

The world first learned to make daguerreotypes from Daguerre's brochure, which became an international best seller within weeks. It was published originally with the imprint of Alphonse Giroux, but apparently in very small number, as only two copies, both in the George Eastman House collection, now exist. However, the identical printed pages and six delicately engraved plates appeared, in large number, with the imprints and advertising inserts of Giroux's rivals: Susse Frères, Molteni et Fils Aîné, and Lerebours. There were six of these variant first editions. A second edition, with a portrait of Daguerre as frontispiece, was issued by Giroux on September 28. Three different English translations appeared. By the end of 1839, Daguerre's directions were available in German, Swedish, Russian, Italian, and Spanish; in the following year, Hungarian and Polish translations appeared.

Samuel F. B. Morse wrote Daguerre, "The first bro-
chure which was opened in America at the bookseller's
containing your exposé of the process, I possess." He
had a camera made and on September 28 took a da-
guerreotype of a church; the exposure was fifteen
minutes. There is evidence that he was preceded by
D. W. Seager, who claimed to have made a daguerreo-
type on September 16. Neither Morse's plate nor
Seager's exists. The earliest existing American da-
guerreotype, a view of the Central High School in
Philadelphia (now in the Pennsylvania Historical So-
ciety), was taken in October by Joseph Saxton with a
camera made from a magnifying glass and a "seegar"
box. It is a poor picture, hardly more than a silhou-
ette, only 1 by $1\frac{1}{2}$ inches in size.

As Jules Janin prophesied, Daguerre's pupils be-
came his demonstrators. They showed, with that ex-
plicitness which no manual can convey, exactly how
the equipment should be used. Furthermore, they ex-
hibited daguerreotypes made by Daguerre himself or
under his tutelage, which showed what results could
be obtained and served as standards by which their
pupils could measure their progress.

François Gouraud, representing himself as Da-
guerre's agent, brought a collection to America in No-
vember, along with a stock of Giroux's cameras. The
exhibition astounded New Yorkers. "The half was
not told us," wrote *The Observer*. "We can find no
language to express the charm of these pictures,
painted by no mortal hand." The Mayor of New York
noted in his diary: "Every object, however minute, is
a perfect transcript of the thing itself; the hair of the
human head, the gravel on the roadside, the texture

of a silk curtain, or the shadow of the smaller leaf re-
flected upon the wall, are all imprinted as carefully as
nature or art has created them in the objects trans-
ferred. . . ." Giroux went to Boston. One of his pu-
pils, Samuel Bemis, bought an outfit on April 15,
1840: with it he took a fine view of King's Chapel with
an exposure of forty minutes.

The daguerreotype was introduced to Vienna by
Andreas Freiherr von Ettingshausen, professor of
physics at the University of Vienna, who happened to
be in Paris when the official publication of the process
took place. At the request of Prince Metternich he
took lessons from Daguerre and upon his return to
Vienna lectured on the daguerreotype.

The Daguerreotype Patented in England

In England, H. de St. Croix, who had attended Da-
guerre's first demonstration, started a series of daily
lectures in London on September 13, 1839. But he
had hardly begun when he received a court order to
cease. An injunction had been requested by one Miles
Berry, who charged him with patent infringement.

Berry was acting for Daguerre and Niépce. Through
him the inventors had secretly applied on July 15 for
a patent. On August 14, the daguerreotype was pro-
tected "in England, Wales and the Town of Berwick
upon Tweed" by Her Majesty's Royal Letters Patent
No. 8194.

The English were incensed. They could not believe
Daguerre's action, so inconsistent with Arago's boast
to the Chamber of Deputies that France was proud
to present the daguerreotype "free to all the world."

John Pye, an engraver who knew Daguerre, wrote him. The inventor replied on October 18:

> Sir,—In answer to your letter of the 4th instant, respecting the process of the Daguerreotype and the patent obtained in England for the same in the name of Mr. Miles Berry, Chancery Lane, previous to any exhibition thereof in France, I beg to state that *it is with my full concurrence that the patent has been so obtained,* and that Mr. Miles Berry has full authority to act as he thinks fit under proper legal advice.
>
> I would add that if you will take the trouble to read attentively the articles of the agreement between me and the French Government, you will see that the process has been sold, not to the civilized world, but to the Government of France for the benefit of my fellow countrymen. . . .
>
> Daguerre.

The first licensee was Antoine Claudet, a native of Lyons, France, who had founded with George Houghton a glass shop in London in 1834. "Immediately on the discovery of Daguerre," he recollected, "I went to Paris, saw him, and bought from him the first license to work out his process under the patent he had taken in England. I came back, brought all the specimens I could procure—made by his pupils, for he was attending once a week at the Conservatoire des Arts et Métiers—to instruct all the adepts and give them the information they wanted to master the process. I sent to the Royal Society's soirées the best specimens, after having submitted a collection of them to the Queen, who kept the best of them."

Less Exposure Time

The second licensee was Richard Beard, a coal merchant speculating in patents, who had imported from America a radically new camera, the patented invention of Alexander S. Wolcott and John Johnson. A concave mirror took the place of a lens; the plate was put in its focus, and consequently was of small size. The camera gave a brighter image than Daguerre's, and with it Wolcott and Johnson were able to make photographic portraits in the fall of 1839. Early in 1840, they opened the world's first photographic portrait studio in New York. To gain maximum illumination, they reflected the sun into the studio with two mirrors. A rack of glass bottles filled with copper sulfate served in place of the blue glass recommended by Arago who, in his lecture on the daguerreotype, noted that the plate was so blue sensitive that by putting a blue glass "between the person posing and the sun, you will have a photogenic image almost as quickly as if the glass did not exist, and yet the illumination being very soft, there will no longer be occasion for grimaces or the too frequent blinking of the eyes."

Beard thought that the American camera was so different from Daguerre's that he could use it without a license. But when Daguerre's agent threatened suit an agreement was reached, and Beard paid £150 per year for the right to make daguerreotypes. A studio was built in London with the huge mirrors hung outside the window, and portraits were regularly made. A reporter from *The Morning Chronicle* visited the

15. Louis Jacques Mandé Daguerre. Daguerreotype by
Jean Baptiste Sabatier-Blot. 1844. George Eastman
House, Rochester, N.Y.

16. Paul Delaroche.
Lithograph by
Charles Baugniet.
1833. George
Eastman House,
Rochester, N.Y.

17. Daguerre's laboratory. Pencil drawing by Charles
Marie Bouton, ca. 1825.

18. A studio corner. Daguerreotype by Daguerre. 1837.
Société française de Photographie, Paris.

19. Fossils. Daguerreotype by Daguerre. ca. 1839.
Conservatoire National des Arts et Méetiers, Paris.

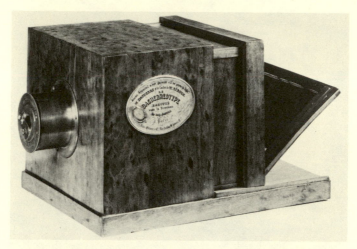

20. An original daguerreotype camera. 1839. George Eastman House, Rochester, N.Y.

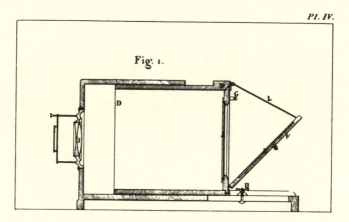

21. Cross section of Daguerre's camera. 1839. George Eastman House, Rochester, N.Y.

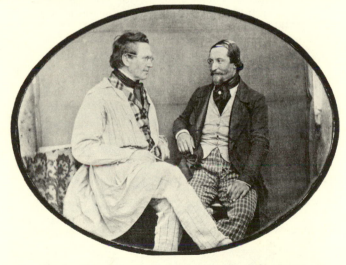

22. Label on daguerreotype camera in George Eastman
House, Rochester, N.Y., with seal of the maker,
Alphonse Giroux, and the signature of Daguerre.

23. Charles Chevalier (left), who built lenses for Daguerre,
and an unidentified companion. Daguerreotype; artist
not known. George Eastman House, Rochester, N.Y.

24A and 24B. Printing the calotypes for *The Pencil of Nature* in Reading, England. Two calotypes by Talbot, ca. 1844.

25. "Scene in a Library." Calotype. Plate 8, *The Pencil of Nature,* 1844.

26. Butterfly wings. Photomicrograph made by Talbot with a solar microscope. ca. 1841. The Science Museum, London.

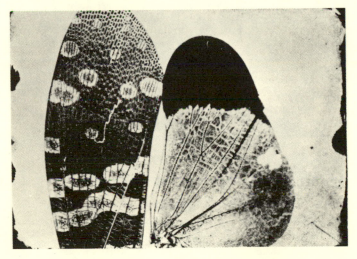

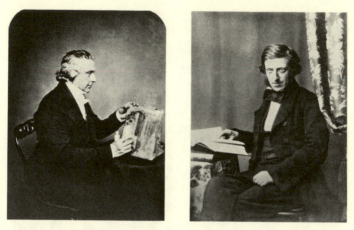

27. Rev. J. B. Reade with a collodion plate sensitizing bath. Photographer not known. The Science Museum, London.

28. Frederick Scott Archer. Photographer not known. The Science Museum, London.

29. Kenilworth Castle. Print from one of Archer's first collodion negatives, 1851. The Royal Photographic Society, Bath, England.

studio in September: "The time required for a person to sit for his portrait is reduced so that under the different circumstances of the intensity of the light, &c., a likeness may be taken in from one to four minutes. At the same time the pain of sitting exposed to the direct rays of the sun is greatly diminished as the light is modified, by being transmitted through coloured glass, so that any person even with the weakest sight can bear it without any inconvenience."

Portraiture, though possible, was hardly practical with exposures of such length, and Beard's operator, John Frederick Goddard, began to experiment with ways to increase the sensitivity of the daguerreotype plate. He found that by subjecting the plate to the fumes of bromine after iodizing, exposures were greatly reduced.

Beard's rival Claudet was driven to similar experimentation. He complained: "I could not use the patented mirror camera of Wolcott, so that I was obliged to do the best I could with Daguerre's slow object glass." He found that chlorine gas acted as an accelerator to the iodized plate. Similar experiments were made in America; soon the use of bromine, chlorine, or a combination of both as an "accelerator"—or, in the lingo of the trade, "quickstuff"—became standard with every daguerreotypist, and portraits were regularly taken at the not unreasonable exposure time of twenty to forty seconds.

Daguerre played no part in the perfection of his process. Although the contract with the French Government clearly specified that he was "obliged to publish any improvements" which he might make "from time to time," he did nothing of any practical value.

On January 4, 1841, Arago announced that Daguerre had discovered an "instantaneous" process, by which windblown trees, running water, the stormy sea, ships under sail and the passing crowd could be photographed in "one or two seconds." When the Minister of the Interior asked for further details, Daguerre begged off. He explained, "I asked M. Arago to communicate it to the Academy only in order to establish the date; for although the principle of this new discovery is certain, the details of it have not yet been sufficiently worked out for me to be able to make it public." Specifications of the new process were published in June in the *Comptes rendus* of the Académie. It was impractical, and Arago felt that he had to apologize to his colleagues. Daguerre announced yet another instantaneous technique in 1844. This, too, was useless.

He was now living in retirement in the village of Bry-sur-Marne, six miles east of Paris. He took up once again his palette and brushes and in 1842 painted a 13- by 19½-foot mural behind the altar of the parish church. It represented, with astonishing reality, an immense nave; the little church was magically transformed into a great cathedral. Nine years later, on July 10, 1851, he died of a heart attack.

LATENT IMAGE

Undaunted by the immediate popularity of the daguer-reotype, Talbot began at once to improve his nega-tive-positive technique. In May 1840, the Graphic Society put some of his recent photographs on exhibi-tion in London. The press was enthusiastic: "The rep-resentation of objects is perfect. Various views of Lacock Abbey . . . ; of trees; of old walls and build-ings, with implements of husbandry; of carriages; of tables covered with breakfast things; of busts and statues; and, in short, of every matter from a botanical specimen to a fine landscape, from an ancient record to an ancient abbey, are given with a fidelity that is al-together wonderful. . . . There is nothing in these pictures which is not at once accurate and pictur-esque." Talbot sent some prints to Herschel. "I am very much obliged indeed by your *very very* beautiful photo-graphs," Herschel wrote. "It is quite delightful to see the art grow under your hands in this way. Had you suddenly a twelvemonth ago been shown them how

you would have jumped and clapped hands (i.e., if you ever *do* such a thing)."

The Calotype

Talbot was now to stumble upon the technique which made his process the basis of all the photographic systems that up to the present have used silver salts: the development of the latent image.

On February 5, 1841, he wrote a letter to *The Literary Gazette* announcing a new process, by which he had taken successful photographs with exposures as short as eight seconds. "It is not easy to estimate exactly how far this increase of sensibility extends: but certainly a much better picture can now be obtained in *a minute* than by the former process in *an hour. . . .*

"The new kind of photographs, which are the subject of this letter, I propose to distinguish by the name of *Calotype.*"

The word was coined from the Greek *kalos,* meaning beautiful, and *typos,* meaning impression.

Further details were given in a letter dated February 19:

"One day, last September, I had been trying pieces of sensitive paper, prepared in different ways, in the camera obscura, allowing them to remain there only a very short time, with the view of finding out which was the most sensitive. One of these papers was taken out and examined by candlelight. There was little or nothing to be seen upon it, and I left it lying on a table in a dark room. Returning some time after, I took up the paper, and was very much surprised to see upon

it a distinct picture. I was certain there was nothing of the kind when I had looked at it before; and, therefore (magic apart), the only conclusion that could be drawn was, that the picture had unexpectedly *developed itself* by a spontaneous action.

"Fortunately, I recollected the particular way in which this sheet of paper had been prepared; and was, therefore, enabled immediately to repeat the experiment. The paper, as before, when taken out of the camera, presented hardly any thing visible; but this time, instead of leaving it, I continued to observe it by candlelight, and had soon the satisfaction of seeing a picture begin to appear, and all the details of it come out one after the other.

"I know few things in the range of science more surprising than the gradual appearance of the picture on the blank sheet, especially the first time the experiment is witnessed."

Talbot's Patent

Talbot patented his calotype process in England, France, and America. Later he was severely criticized for this action, which was considered a hindrance to the progress of the art and science of photography.

He did not undertake this lightly. In 1839, when he disclosed his first "photogenic drawing" process freely and without restriction to the Royal Society, it was against the advice of his friend Sir David Brewster, who had urged him to protect his invention by a patent. Talbot was not interested then in the commercial aspects of his invention. He published his experiments in the true spirit of scientific inquiry.

But in 1841 the situation changed: Daguerre had protected his rival process by a zealously guarded patent. That England alone was deprived of the invention which the French Government proposed "to give freely to the whole world" (*"en doter libéralement le monde entier"*) seemed almost like revenge. Why, but for Talbot, did Daguerre single out England? Both Daguerre and Isidore Niépce were well recompensed by their country for their invention; Talbot financed his work out of his own pocket. Daguerre's English licensees were already profiting; one of them, Richard Beard, had already secured a patent for the reflecting camera of Wolcott and Johnson. If he was to recover the bare expenses of his long research, Talbot had no other course than to secure his invention by a patent.

He was no stranger to patents; he had already obtained one for an internal combustion engine, which operated by the electrolytic decomposition of water into hydrogen and oxygen. The gases were ignited; the explosion drove a piston in a cylinder.

Talbot asked the advice of Herschel. His friend replied: "You are quite right in patenting the calotype. With the liberal interpretation you propose in exercising the patent right no one can complain. And I must say I have never heard of a more promising subject for a *lucrative* patent of which I heartily give you joy."

According to British patent law, provisional specifications, constituting a claim, are sufficient to protect an inventor. Within six months he must file "a particular description of the nature of said invention, and in what manner the same is to be performed." The

patent was then enrolled. Talbot applied for the patent on February 8, 1841. Thus protected, he described the new technique in detail to the members of the Royal Society on June 10. The communication was printed in the Society's *Proceedings* and privately by Talbot in a brochure. The almost identical specifications were filed on July 19.

He first prepared a quantity of what he called *"iodized paper."* He coated one side of a "sheet of the best writing-paper" with a weak solution of silver nitrate, dried it, and then dipped it into a solution of potassium iodide. Because the silver iodide thus produced had halide in excess, the paper was of relatively low sensitivity. "It may be kept for any length of time," Talbot said, "without spoiling or undergoing any change, if protected from the light. This is the first part of the preparation of calotype paper, and may be performed at any time. The remaining part is best deferred until shortly before the paper is wanted for use.

"When that time is arrived, take a sheet of the *iodized paper* and wash it with a liquid prepared in the following manner:

"Dissolve 100 grains of crystallized nitrate of silver in two ounces of distilled water; add to this solution one-sixth of its volume of strong acetic acid. Let this mixture be called A.

"Make a saturated solution of crystallized gallic acid in cold distilled water. The quantity dissolved is very small. Call this solution B.

"When a sheet of paper is wanted for use, mix together the liquids A and B in equal volumes, but only mix a small quantity of them at a time, because the

mixture does not keep long without spoiling. I shall call this mixture the *gallo-nitrate of silver*.

"Then take a sheet of *iodized paper* and wash it over with this *gallo-nitrate of silver,* with a soft brush, taking care to wash it on the side which has been previously marked. This operation should be performed by candlelight. Let the paper rest half a minute, and then dip it into water. Then dry it lightly with blotting-paper, and finally dry it cautiously at a fire, holding it at a considerable distance therefrom. When dry, the paper is fit for use."

Talbot stated that the calotype paper was "sensitive to light in an extraordinary degree, which transcends a hundred times or more that of any photographic paper hitherto described."

Exposure produced no visible image. "The impression is latent and invisible, and its existence would not be suspected by any one who was not forewarned of it by previous experiment.

"The method of causing these impressions to become visible is extremely simple. It consists in washing the paper once more with the *gallo-nitrate of silver,* prepared in the way before described, and then warming it gently before the fire. In a few seconds the part of the paper upon which the light has acted begins to darken, and finally grows entirely black, while the other part of the paper retains its whiteness. . . . It is a highly curious and beautiful phenomenon to see the spontaneous commencement of the picture, first tracing out the stronger outlines, and then gradually filling up all the numerous and complicated details. The artist should watch the picture as it develops itself, and when in his judgment it has attained the

greatest degree of strength and clearness, he should stop further progress by washing it with the fixing liquid."

Talbot used potassium bromide for fixing. In a subsequent patent of 1843 he specified hypo: "I claim the use of hot or boiling solutions of the hyposulphites, in order to give increased whiteness to calotype and other photographic pictures, and at the same time make them more permanent. . . ."

Physical and Chemical Development

The most significant part of Talbot's patent was his technique for making visible the latent image, that is, turning the exposed silver halide grains—and *only* them —to silver.

In the print-out process the metallic silver making up the image is formed solely by the action of light upon the silver halide. In the developing-out process light reduces to silver only extremely minute portions of the silver halide grains. The silver specks thus formed are so small that they are invisible. Talbot was unaware of their existence, which was proved only recently with powerful electron microscopes. Talbot's gallo-nitrate of silver contains silver ions, which, on the surface of the silver specks are reduced to silver by the action of the gallic acid. The silver of the specks acts as a catalyst for this process. The gallo-nitrate of silver is replenished with silver ions by the dissolution of the silver halide of the grains. The function of the acetic acid is to inhibit the reaction which, unrestrained, might cause the unexposed silver halide grains to be reduced to silver.

This method of making visible the latent image is called *physical development*. It does not depend upon the halide component of the silver halide grains; the halides can even be removed by fixing with hypo before development. Physical development was replaced in 1862 by *chemical development*. The developing agent is in alkaline solution; no silver is present. The exposed silver halide grains are reduced to metallic silver. Talbot played no direct part in the discovery of this method of developing the latent image, which became universal with the introduction of gelatino-bromide emulsions. He was, however, the first to conceive of a photographic system in which silver is produced from silver halides by the combined action of light and development. In Daguerre's process silver was produced by light action alone. The image was not visible due to the nature of the support, which itself was silver; this latent image was made visible by changing the silver to an amalgam by the action of mercury. The principle of the daguerreotype process became obsolete shortly after Daguerre's death.

Talbot's concept of the development of the latent image is basic to all silver halide photographic systems to the present day.

"THE PENCIL OF NATURE"

With the perfection of the calotype, Talbot's negative-positive process became a strong competitor to the daguerreotype. It had several advantages over Daguerre's direct positive process. The materials were cheaper, the apparatus far less cumbersome, and the processing much simpler. Instead of expensive silver-plated copper plates handmade by silversmiths and stamped with their hallmarks, any good quality drawing paper could be used. Instead of bulky sensitizing boxes and mercury baths, only a few graduates, a scale, a set of trays and a printing frame were required. Instead of the laborious buffing of the plate, fuming it with potentially lethal gases of iodine, bromine, chlorine, and developing it with toxic volatile mercury, the paper was dipped in successive, and relatively harmless, solutions.

The greatest advantage of Talbot's invention was that limitless identical copies could be made from a single master negative. Photographs could be pub-

lished as single sheets, like engravings, or pasted in the pages of books to serve as illustrations.

Talbot's Book

Talbot himself produced the first of these photographically illustrated books: *The Pencil of Nature.* He described this project in a prospectus, dated June 1844:

> The Daguerreotype is now well known to the public, having been extensively used for taking portraits from the life, while the English art (called *Photogenic Drawing,* or the *Calotype*) has been hitherto chiefly circulated in private societies, and is consequently less generally known.
>
> It has been thought, therefore, that a collection of genuine specimens of the art, in most of its branches, cannot fail to be interesting to a large class of persons who have hitherto had no opportunity of seeing any well-executed specimens. It must be understood that the plates of the work now offered to the public are the pictures themselves, obtained by the action of light, and not engravings in imitation of them. . . .
>
> It is proposed to publish the Work in Ten or Twelve Monthly Parts, in Royal quarto, price Twelve Shillings each, each Part containing Five Plates, with descriptive letter-press.

Six installments, containing twenty-four plates in all, were published by Longman, Brown, Green, and Longmans of London between June 1844 and April 1846. The photographs mounted on the blank pages of the book were printed at a laboratory Talbot had estab-

lished at Reading, under the direction of Nicholaas Henneman, who formerly had been a servant at Lacock Abbey and Talbot's assistant in his photographic research. The Reading Talbotype Establishment, as it was called, was the world's first mass-production photofinishing laboratory: between April 15 and May 25, 1844, a thousand prints—two hundred each from five negatives—were supplied for the first issue of *The Pencil of Nature*.

The prints were all made on a print-out silver chloride paper similar to Talbot's photogenic drawing paper of 1839, except that ammonia was added to the silver nitrate solution. They were exposed to sunlight on racks in the backyard of the Reading Talbotype Establishment. The printing was laborious, for exposures varied in length according to the intensity of the sunlight, from minutes upwards to an hour. The exposed prints were fixed in hot hypo.

Talbot chose subjects for *The Pencil of Nature* which would illustrate the potentials of his invention: recording, in exact detail, architecture and sculpture; multiplying printed pages; reducing or enlarging drawings and paintings; preserving records by duplication; contact printing botanical specimens; making pictorial inventories of *objets d'art* or the contents of a library. He predicted photography by invisible radiation:

> When a ray of solar light is refracted by a prism and thrown upon a screen, it forms there the very beautiful coloured band known by the name of the solar spectrum.
>
> Experimenters have found that if this spectrum is thrown upon a sheet of sensitized paper, the violet end of it produces the principal effect:

and, what is truly remarkable, a similar effect is produced by certain *invisible rays* which lie beyond the violet, and beyond the limits of the spectrum, and whose existence is only revealed to us by this action which they exert.

Now, I would propose to separate these invisible rays from the rest, by suffering them to pass into an adjoining apartment through an aperture in a wall or screen of partition. This apartment would thus become filled (we must not call it *illuminated*) with invisible rays, which might be scattered in all directions by a convex lens placed behind the aperture. If there were a number of persons in the room, no one would see the other: and yet nevertheless if a *camera* were so placed as to point in the direction in which any one were standing, it would take his portrait, and reveal his actions.

For, to use a metaphor we have already employed, the eye of the camera would see plainly where the human eye would find nothing but darkness.

Alas! that this speculation is somewhat too refined to be introduced with effect into a modern novel or romance; for what a *dénouement* we should have, if we could suppose the secrets of the darkened chamber to be revealed by the testimony of the imprinted paper.

In 1845 Talbot brought out a second book with calotype illustrations: *Sun Pictures in Scotland,* containing twenty-three plates. Some 118 copies were sold —a total laboratory production of 2714 photographs. The pictures represented "scenes connected with the life and writings of Sir Walter Scott." There was no text.

Uses for Calotype

Scotland adopted the calotype process with enthusiasm. Sir David Brewster experimented with his friend's process as soon as he received the specifications. He persuaded Robert Adamson to open a studio in Edinburgh. When the painter David Octavius Hill decided to paint a group portrait of all 450 delegates to the First General Assembly of the Free Protesting Church of Scotland, Brewster suggested that he photograph the sitters. "I got hold of the artist," Sir David wrote Talbot, "showed him your calotype and the eminent advantage he might desire from it in getting likenesses of all the principal characters before they dispersed to their respective homes. He was at first incredulous, but went to Mr. Adamson, and arranged with him the preliminaries for getting all the necessary Portraits. They have succeeded beyond their most sanguine expectations—They have taken, on a small scale, groups of 25 persons in the same picture all placed in attitudes which the painter desired, and very large pictures besides have been taken of each individual to assist the Painter in the completion of his picture. Mr. D. O. Hill the painter is in the act of entering into partnership with Mr. Adamson and proposes to apply the Calotype to many other general purposes of a very popular kind. . . . I think you will find that we have, in Scotland, found out the value of your invention not before yourself, but before those to whom you have given the privilege of using it. . . . The Daguerreotype is considered infinitely inferior, for all practi-

cal purposes, notwithstanding its beauty and sharp-
ness."

Despite the success of the Hill-Adamson studio, the
calotype was little used for portraiture. Talbot per-
suaded Daguerre's licensee Antoine Claudet to use it
in his London studio, and for a while Claudet offered
the public both calotypes and daguerreotypes; his sit-
ters preferred daguerreotypes. A miniature painter,
Henry Collen, was more successful—largely because he
had artistic skill to retouch the prints. Talbot opened
his own portrait studio in London in 1847, under the
management of Henneman and Thomas Augustine
Malone, but it was financially unsuccessful. *The Art
Union* wrote that the portraits they had seen were
"exceedingly beautiful, but inferior on the whole to the
artistic photography of Messrs. Hill and Adamson of
Edinburgh. . . ."

The calotype met with its greatest success in the re-
cording of architecture and landscapes. Ironically, it
came to its highest peak, both in quality and pro-
duction, in Daguerre's native land. Although Talbot
had secured a French patent, he apparently did not en-
force it. A team of photographers produced an inven-
tory of great medieval buildings and sculpture for the
government; some of the paper negatives, made with
giant cameras, were as large as 20 by 29 inches.
Calotypes were taken on expeditions to Egypt and the
Middle East, and in India. A Photographic Printshop
(Imprimerie Photographique), similar to the Talbo-
type Establishment at Reading, was opened in Lille by
Louis Desiré Blanquart-Evrard. Unlike Talbot, he
printed on developing-out paper. This method speeded
up production, for the exposures were much shorter

than with silver chloride, or "salted" print-out paper. He was able to produce upwards of a hundred prints an hour, with exposures of two to twenty seconds.

Perfecting the Process

But although the calotype process made possible the mass production of prints, it had the disadvantage that the images lacked the brilliance and extraordinary definition of the daguerreotype. Paper is a poor support for a negative; its texture is reproduced on the positive together with the silver image. Talbot tried to correct this unwelcome presence by waxing the negatives after processing to make them somewhat more transparent. It was obvious that glass would be a more suitable support. Herschel had already recognized this in 1839, but had not perfected his technique. The first successful solution to this problem was published by Claude Abel Niepce de Saint-Victor, the nephew of Nicéphore Niépce, in 1847. He coated a glass plate with white of egg and potassium iodide. When the plate was dry, he plunged it into silver nitrate, thus forming light-sensitive silver iodide. After exposure, he developed the latent image with gallic acid. Talbot discovered a similar process in 1851. These *albumen plates,* as they came to be known, were generally too insensitive to be practical. Talbot used them, however, for a dramatic experiment: instantaneous photography by electric spark. He fastened a copy of *The Times* to a wheel, which he rapidly revolved so that the newspaper was but a white blur. He then uncapped the lens of a camera already focused upon the revolving wheel and closed an elec-

trical circuit producing a brilliant spark. When the picture was developed, the masthead of *The Times* could be read. Talbot wrote, prophetically:

"From this experiment the conclusion is inevitable, that it is in our power to obtain the pictures of all moving objects, no matter in how rapid motion they may be, provided we have the means of *sufficiently* illuminating them with a sudden electric flash. But here we stand in need of the kind assistance of scientific men who may be acquainted with methods of producing electrical discharges more powerful than those in ordinary use. What is required, is, vividly to light up a whole apartment with the discharge of a battery: the photographic art will then do the rest, and depict whatever may be moving across the field of view."

Talbot patented these plates. He noted that if viewed against a dark background they appeared positive, and so he called them amphitypes (from the Greek *amphi,* of both kinds). In his report on this invention, in *The Athenaeum* for December 6, 1851, he noted: "Since the time when I first observed them, the Collodion process has become known, which produces pictures having almost the same peculiarity. In a scientific classification of photographic methods, these ought therefore to be ranked together as species of the same genus."

Collodion is a viscous solution of cellulose nitrate in a mixture of alcohol and ether, somewhat the consistency of corn syrup. When the solvents evaporate the remainder becomes a tough, skinlike film. An Englishman, Frederick Scott Archer, proposed, in March 1851, the use of collodion as a medium for binding light-sensitive silver salts to glass. He added potassium

iodide to colodion, which he poured on a glass plate, and then, before the coating had dried, dripped it into a solution of silver nitrate. Thus silver iodide was formed in suspension. He exposed the plate *while wet* and then developed it at once with gallic or pyrogallic acid. He fixed the plate with hypo, washed it, and dried it. To conserve glass, he stripped the emulsion from the plate, and rolled it up on a glass rod. Later this practice was dropped, and the emulsion left upon the glass.

This collodion or "wet plate" process was universally hailed. "Daguerreotypists everywhere," one of them wrote, "threw down the instruments of a complicated and laborious business, the buff and buff-wheel, the iodine, bromine and mercury pots, the developing boxes and gilding stands, for the directness and simplicity of the collodion process. . . ." By 1854 there was hardly a portrait gallery in London that was not using the new process, to the exclusion of both the daguerreotype and the calotype.

A UNIVERSAL TECHNIQUE

Talbot's Patent Goes to Court

Talbot considered the collodion process an infringement of his calotype patent. Although he had relinquished all rights to the use of his invention by amateurs, at the combined appeal of the presidents of the Royal Academy and the Royal Society, he still zealously guarded the rights for professional use, and through his lawyers he threatened any portrait photographers who were using wet plates. Some capitulated, and either bought licenses from Talbot or went out of business. A few fought. James Henderson, who had two London studios, resisted and was haled to court. Talbot, with the help of affidavits from Herschel and Brewster, won an injunction, and Henderson was ordered to cease using Archer's invention. The lawyers published the following notice in *The Athenaeum* as a warning:

PHOTOGRAPHIC PORTRAITS—Collodion Process—*Caution*—Talbot *v.* Henderson. His Honour Vice-

Chancellor Wood has this day issued an injunction to restrain the defendant from making and selling Photographic Portraits by the above process without the licence of the patentee. Artists and others desiring to practice this branch of the Photographic Art are requested to apply to us. All infringers of the patent rights will be proceeded against. Price & Bolton, 1, Lincoln's Inn, New-square, May 26, 1854

About this same time, action was brought against another portraitist, Martin Laroche, who threatened a countersuit and appealed to his brother professionals for help. Talbot marshaled forces for the contest. He wrote William Thomas Brande, England's leading chemist and author of a standard textbook:

I am engaged in legal proceedings against a person for infringing my patent called the Calotype Photographic process. This invention I freely presented to the Public 2 years ago, reserving only one point. But the infringers being resolved to disregard my rights, I have appealed to the protection of the law. . . . I should be much obliged therefore if you would kindly consent to give scientific evidence on my behalf, especially as my friend Herschel, whose Evidence would be invaluable, has an objection to appearing in a Court of Law and therefore it is not our intention to ask him. The points on which I would request your testimony are first, the general notoriety of the invention in the Scientific World, as attributed to me (the defend[t] denying that I was the inventor). Secondly—the chemical similarity of the process called Calotype and that which Employs Collodion, both forming an image upon a

surface of iodide of silver moistened with nitrate
of silver, and developing the photographic image
with gallic acid. The defend[t] relying upon the
fact that I have spoken of *paper,* and that *collodion*
is not *paper,* which I willingly admit but consider
the point a secondary one since the Collodion acts
instead of the paper, as a support to the iodide of
silver. I shall be happy to send you a printed copy
of the specifications and to perform any photo-
graphic experiment in your presence that you may
deem requisite to enable you to form a satisfac-
tory opinion although I doubt not but that you are
perfectly familiar with the subject in all its
bearings.

Brande agreed to testify, and Talbot sent him the
patent specifications and "a copy of a certain affidavit
made by Sir D. Brewster, which puts the point in dis-
pute between me and the infringers in a clear and
lucid form. . . ."

The case, after many postponements, came to trial
on December 18, 1854. Talbot's lawyers put nine ex-
perts on the witness stand, all of whom testified that
the calotype and collodion processes were basically
the same. Laroche's lawyers, in defense, argued that
Talbot was not entitled to the patent in the first place,
and even if the patent could be considered valid, it
did not cover the collodion process. Their chief wit-
ness was the Reverend Mr. Reade, who testified that
he began using gallic acid to sensitize paper in 1837,
that he exhibited photographs made by this technique
at a Royal Society soirée on April 27, 1839, and at
that meeting he had disclosed his technique to Tal-
bot. On cross-examination, he stated that he "had not

the slightest notion" of the idea of developing a latent image "until he learned it from Mr. Talbot," and that the only documents in which he had detailed his process prior to Talbot's patent were a letter he had written to E. W. Brayley on March 9, 1839, and a similar private communication to his brother. The defense argued that the analogy drawn by Talbot between collodion and paper as a support for light-sensitive silver iodide was false. *The Photographic Journal* reported: "Mr. Robert Hunt, a Fellow of the Royal Society and formerly Professor of Physical Science in the Government School of Mines, said his attention had been turned to photography ever since the earliest announcement of Daguerre's discovery; both to the Daguerreotype, the Talbotype and the collodion process. If you took the film of collodion off the glass without iodine, and treated it as Mr. Talbot treated his iodized paper, he had no doubt, it being dry, that no image could be produced upon it. It was necessary in the collodion process that iodine should be used before the film was formed." Furthermore, he pointed out, "pyrogallic acid was certainly not the same thing as gallic acid." Another witness, when asked for a popular illustration of the difference between these reducing agents, answered, "They are like sugar and vinegar in my opinion." Lord Chief Justice Jervis was perplexed and confused. He prefaced his lengthy and repetitious charge to the jury with a confession: "I will proceed to explain, as far as I can in a few words, what I deem to be the nature of this invention. I confess I am afraid I do not understand it, because there are many views which have occurred to me in considering it which have escaped my learned brother

and the other parties, and I do not think, therefore, that I entirely understand the subject; but I will endeavour, as far as I can, to ascertain whether I do."

The Chief Justice Interprets Patent Law

He first explained the elements of patent law: In return for the monopoly of a patent the public "gets the present use of the invention through the means of the inventor, and at the end of fourteen years the means of doing it without qualification or restriction, by obtaining from the specification a perfect explanation of what is to be done." A patent, the judge said, cannot be for a principle; it can be only for "some means or manner of manufacture." The specifications must be exact, and the claims must not include what is in the public domain. To illustrate this the Chief Justice quoted that part of Talbot's patent regarding the use of potassium iodide.

"I am aware [wrote Talbot] that the use of iodide of potassium for obtaining . . . photographs has been recommended by others, and I do not claim it here by itself as a new Invention, but only when used in conjunction with the gallo-nitrate of silver, or when the pictures obtained are rendered visible or strengthened subsequently to their first formation."

The judge told the jury that Talbot was "obliged" to recognize others' recommendation of potassium iodide. "If he had claimed it, as it has been used by others, everybody would agree with me that the specification would be bad."

By the same reasoning the Chief Justice interpreted

with equal literalness each of Talbot's four basic claims.

> *Talbot's first claim:* ". . . employing gallic acid or tincture of galls, in conjunction with a solution of silver, to render paper which has received a previous preparation more sensitive to the action of light."
>
> *The Chief Justice:* ". . . what he claims is first a mixed solution of gallic acid and nitrate of silver for a particular purpose to make the paper more sensitive."
>
> *Talbot's second claim:* "the making visible photographic images upon paper, and the strengthening such images when already faintly or imperfectly visible by washing them with liquids which act upon those parts of the paper which have been previously acted upon by light."
>
> *The Chief Justice:* "If it is that he claims *all* liquids, that is claiming something like a principle, and the patent is bad; because a man has no right to say 'I claim everything which will do it and I leave you to speculate upon what will do it.' He is bound to state what will do it, and therefore the only way to make this a good claim is to say, 'I claim, secondly, the making visible photographic pictures upon paper, and the strengthening such images when already faintly or imperfectly visible by washing them with the liquids hereinbefore mentioned . . . gallo-nitrate of silver or something equivalent to it. . . .' Mr. Laroche and those who practise the collodion principle use generally pyrogallic acid or they may use proto-sulphate of iron or proto-nitrate of iron. We will say pyrogallic acid. Is that the same, or is it a chemical equivalent for

gallo-nitrate of silver? If it is the same or known to be a chemical equivalent, he has no right to use it, it is an infringement. . . ."

Talbot's third claim: ". . . the obtaining portraits from the life by photographic means upon paper."

The Chief Justice: "That is an unhappy claim. . . . I am afraid it will turn out to be a bad claim. But for the purposes of the day, I construe it to mean 'the obtaining portraits by the photographic means hereinbefore described.' I am bound to do that for the purpose of making it a perfect claim. . . ."

Talbot's fourth claim: "The employing bromide of potassium, or some other soluble bromide, for fixing the images obtained."

The Chief Justice: "The fixture as claimed is not discussed or in dispute . . . therefore you may dismiss that, except in passing when we come to the history of the inquiry."

There were, the judge observed, two aspects of the testimony of the Reverend Mr. Reade. Was his invention the same as Talbot's? Was it published?

Talbot specified the use of gallo-nitrate of silver for two functions: sensitization and development. By his own admission, Reade did not use gallic acid as a developer. But even if Reade's invention was *identical* to the calotype, the judge noted, it would not invalidate Talbot's patent, because he had not made it public.

"The mere knowledge of the art locked in the bosom of Mr. Reade . . . is not sufficient to disentitle Mr. Talbot to his patent, and though he may have distributed among his friends thousands of sun-pictures,

that will not have the effect of disclosing the process.
. . . There may be two first and true inventors, both
may be running the race at the same time, the one may
keep it secret and the other give it to the public, and
the one who gives it to the public and gets the patent
will have the benefit of it."

Finally, the Chief Justice charged the jury with two
questions:

"Did Mr. Reade know of the use of nitrate of silver
with gallic acid, in connexion with iodide of potassium?
Knowing it alone will not do; if he had that knowledge
before February, 1841, did he make that knowledge
public and known? If he did, then you must say that
Mr. Talbot is not, for the purposes of the patent, the
first and true inventor. . . .

"Is the use of collodion simply with nitrate of silver
and iodide of potassium . . . the same as the use of
paper with nitrate of silver, iodide of potassium, and
gallic acid? . . . Is pyrogallic acid . . . a chemical
equivalent with gallo-nitrate of silver? If it is, the de-
fendant is guilty; if it is not, he is not guilty."

The Verdict and Its Effect

The jurors retired and were absent for three quarters
of an hour. Upon their return they handed a note to
the court.

> *The Chief Justice:* "You find that Mr. Talbot was
> the first and true inventor within the meaning
> of the patent laws?"
> *The Foreman:* "Yes—that he was the first to pub-
> lish."

The Chief Justice: "You find that the Defendant was not guilty?"
The Foreman: "Yes."

Thus, the most critical patent suit in the history of photography concluded with a double verdict.

Talbot expressed his disappointment in a letter to his wife:

"The jury understood little of the subject, but trusted to the judge, and the judge fell into awful mistakes, not being able to comprehend the process which he had never tried. It is impossible we can rest content with the summing up of the judge."

From a strictly scientific view, Talbot was correct in his belief that the collodion process was of the same genus as his calotype. The mechanics of both are identical: they both rely upon the physical development of the latent image. Talbot was defeated by the judge, who narrowly interpreted the patent claims and took little notice of the testimony of Talbot's experts. It is true that pyrogallol and gallic acid are different chemicals,* but their action as developing agents, in

* Their structural formulas are given by C. E. K. Mees, in his *The Theory of the Photographic Process,* as

Gallic acid Pyrogallol

FIGURE 8

the presence of free silver ions in acid solution, is identical.

From the ethical view, Talbot's aggressiveness in relentlessly prosecuting alleged infringers of his patent has been criticized roundly. It is strange that he did not challenge Archer when he freely published in *The Chemist* for March 1851 the collodion process. Photographers naturally felt that such a publication was public property; they were rightfully indignant that, years later, after having abandoned both the daguerreotype and the calotype in favor of the collodion process, they found themselves, often without warning, threatened by Talbot. His lawyers were ruthless; and their ways were often harsh. Thomas Sims, who had been in business seven years, received a letter from Talbot, praising his mastery of the collodion technique, and requesting an interview. Flattered by the invitation of so eminent a man, Sims hastened to the rendezvous. There he found waiting for him, not Talbot, but his solicitor, who advised Sims that, in using the collodion process for professional portraiture, he was guilty of patent infringement, and that he would have to buy a calotype license at £350 per year. To Sims this sum was staggering. He refused to pay it. Thereupon Talbot's lawyers served an injunction and Sims received a court order to close business.

Talbot's defeat was hailed by the profession. The shackles put upon photography by Daguerre and Talbot were forever broken. British patents expire in fourteen years, unless renewed. Talbot never appealed the Laroche case, and abandoned his plan to renew the calotype patent. With Laroche's victory the calotype process joined the daguerreotype in obsolescence.

But Talbot's basic concepts, the negative-positive system and the development of the latent image, live on. Collodion gave way to gelatin as a support for light-sensitive silver halides; glass gave way to transparent film as a support for them; physical development gave way to chemical development; color sensitivity, limited in the calotype process to blue, violet, and ultraviolet, was increased to embrace the rest of the spectrum and the infrared. All these improvements, which make the silver photographic systems of today so versatile, are based on Talbot's invention.

Yet without Daguerre's challenge and his establishment of a successful photographic technique which convinced the world of the potentials of "the spontaneous reproduction of the images of nature received in the camera obscura," Talbot's work might have remained buried in the attic of Lacock Abbey, along with his never perfected internal combustion engines.

Without Niépce's laborious struggles, Daguerre might have remained a minor painter of popular spectacles. Yet without Daguerre's help, Niépce might never have been heard of after his discouraging and futile attempt to bring his invention to light in England.

The discoveries of these pioneers were tempered by the trials and errors of thousands the world over. When the glass negatives of Archer replaced the metal plates of Daguerre and the paper negatives of Talbot, the words daguerreotype and calotype dropped from common usage. One word became universal: photography.

BIBLIOGRAPHY

Arnold, H. J. P. *William Henry Fox Talbot*. London 1977.

Daguerre, Louis Jacques Mandé. *Historique et description des procédés du Daguerréotype et du Diorama*. Paris 1839.

———. *An Historical and Descriptive Account of the Various Processes of the Daguerréotype*. London 1839.

Eder, Josef Maria. *History of Photography*. New York 1978.

Fouque, Victor. *The Truth Concerning the Invention of Photography: Nicéphore Niépce, His Life and Works*. New York 1935.

Gernsheim, Helmut and Alison. *The History of Photography*. London 1954.

———. *L. J. M. Daguerre*. London 1956.

———. "Talbot's and Herschel's Photographic Experiments in 1839." *Image*, 8:133–37 1959.

Kravets, T. P., ed. *Dokumenti po Istorii Izobreteniya Fotografi*. Moscow 1949 (Niépce's correspondence in French and Russian).

Mees, C. E. K. *The Theory of the Photographic Process*. New York 1942.

Newhall, Beaumont. *The Daguerreotype in America*. New York 1976.

———. *The History of Photography*. New York 1982.

Potonniée, Georges. *History of the Discovery of Photography*. New York 1936.

Schultze, R. S. "Rediscovery and Description of Original Material on the Photographic Researches of Sir John F. W. Herschel." *Jour. Phot. Science*, 13:57–68 1965.

Taft, Robert. *Photography and the American Scene.* New York 1938.

Talbot, William Henry Fox. *The Pencil of Nature.* London 1844–46.

SOURCE NOTES

CHAPTER I: DAGUERRE'S SECRET

First announcement: *Literary Gazette*, 1147:28 1839. Arago's report: *Comptes rendus de l'Académie des Sciences*, 8:4–6 1839.

CHAPTER II: TALBOT'S DILEMMA

Talbot's challenge: *Comptes rendus*, 8:171 1839. His early use of cameras and concept of photography: Talbot, *Pencil*. Exhibits photogenic drawings at Royal Institution: *Lit. Gaz.*, 1150:74–75, 1160:236 1839. Communicates process to Royal Society: *Athenaeum*, 589:114–16 1839.

CHAPTER III: NIÉPCE, THE ALMOST-FORGOTTEN PIONEER

The Académie answers Talbot: *Comptes rendus*, 8:173 1839. Niépce's correspondence: Fouque, 62, 64, 65, 68, 70, 87, 95; Kravets, 149.

CHAPTER IV: HELIOGRAPHY

Niépce's correspondence: Fouque, 142, 143; Kravets, 171, 193, 205, 238, 244, 248. Description of first photograph: H. Gernsheim, *Phot. Jour.*, 92A:118 1952.

CHAPTER V: PARTNERSHIP BY CORRESPONDENCE

Daguerre–Niépce correspondence: Kravets, 255, 286, 301, 337, 371, 373, 374, 403.

CHAPTER VI: THE DAGUERREOTYPE

Daguerre–Isidore Niépce correspondence: Kravets, 417, 427, 432, 451, 459, 463.

CHAPTER VII: "THE ART OF PHOTOGENIC DRAWING"

Talbot's defense of his announcement: *Lit. Gaz.*, 1160:236 1839. Brewster's advice: Gernsheim, *History,* 69. Talbot's working directions: *Lit. Gaz.*, 1153:123 1839. On light sensitivity of silver chloride: Talbot, *Pencil.* Crystalline structure of silver chloride: Mees, 9–17. Talbot to Arago: *Comptes rendus,* 8:305 1839.

CHAPTER VIII: HYPO

Herschel's notebook: I am indebted to the Science Museum, London, for permission to quote from the original manuscript. Herschel on "hypo": *Edinburgh Philosophical Jour.,* 1:8–29 1819. Herschel to Talbot: Schultze, 62; Gernsheim, "Talbot," 136. Talbot to Biot: *Compte rendu* 8:341 1839.

CHAPTER IX: CONTENDERS FROM ALL SIDES

Bauer: *Lit. Gaz.*, 1154:138 1839; Kravets, 480, 464, 475, 470. Royal Society conversazione: *Athenaeum,* 594:204 1839. Talbot on silver bromide paper: *Lit. Gaz.*, 1158:201–2 1839. His controversy with Willmore and Havell: *Lit. Gaz.*, 1159:215; 1160:235, 236 1839. Herschel on enlarging: *Lit. Gaz.*, 1160:236 1839. Herschel on photography: *Philosophical Transactions,* 130:8–9 1840. A. T. Gill, "A Letter by Joseph Bancroft Reade, 1 April 1839," *Phot. Jour.* 101:11 1961; *Phot. Jour.* 2:92 1854; D. Thomas, *First Negatives,* 1964, p. 9. Florence: B. Kossoý, *Hercules Florence,* São Paulo, 1977, p. 50.

CHAPTER X: A SPATE OF EXPERIMENTS

Draper: his *ScientificMemoirs,* New York 1871, 197, 80; *Amer. Jour. Phot.,* ns 1:3 1858. Lassaigne: *Compte rendu,*

8:547 1839. Fyfe: *Philosophical Magazine,* 14:463 1839.
Bayard: G. Potonniée, *Bul. Société Française de Phot.,* ser.
3, 4:366-74 1913. Breyer: *Bul. Académie Royale des
Sciences . . . de Bruxelles,* 8:370-75 1839. Ponton: *Edin-
burgh New Philosophical Jour.,* 27:169-71 1839. Steinheil
and Kobell: H. and A. Gernsheim, "The First Photographs
Taken in Germany," *Image,* 9:38-43 1960. Robison:
Athenaeum, 606:435 1839. Forbes: J. C. Shairp, *Life . . .
of James David Forbes,* London 1873, 241-42. Herschel:
Compte rendu, 8:838 1839; Thomas, 6; Gernsheim,
"Talbot," 136-37.

CHAPTER XI: DAGUERRE'S TRIUMPH

Morse: New York *Observer,* Apr. 20 1839. Diorama
fire: P. Harmant, *Le Photographe,* 52:141 1962. Arago:
his *Œuvres,* 12:724 Paris 1859. Delaroche: *Image,* 11:26
1962. Government purchase agreement: Gernsheim, *Da-
guerre,* 90, 93. Giroux contract: *Phot. Jour.,* 78:33–34
1938. Verification of dates of political action: P. Harmant,
Le Photographe, 52:627–28 1962. Arago's report at Aug.
19 meeting: *Compte rendu,* 9:250-67 1839; *Athenaeum,*
617:637 1839; *Lit. Gaz.,* 1179:539 1839; *L'Artiste,* ser.
2, 3:277 1839; *Le Figaro,* Sep. 8 1839; *Le Charivari,* Aug.
30 1839; Daguerre, *History* (Memes translation), 75.

CHAPTER XII: THE MIRACULOUS MIRROR

L'Artiste, ser. 2, 4:1-3 1839. *Le National,* Sep. 8 1839.
Talbot on the daguerreotype: British Association for Ad-
vancement of Science, *Report of Ninth Meeting,* 1839,
3–5; *London, Edinburgh and Dublin Philosophical Mag.,*
22:96-97 1843. Donné: *Compte rendu,* 9:376-78 1839.
Draper: *London, Edinburgh and Dublin Philosophical Mag.,*
22:367-68 1843.

CHAPTER XIII: INTERNATIONAL SUCCESS

Morse to Daguerre: Newhall, *Daguerreotype,* 21. Gou-
raud: Newhall, *Daguerreotype,* 28. Daguerre to Pye:

Athenaeum, 626:813 1839. Claudet: *Philadelphia Phot.,* 5:174 1868. Beard studio: London *Morning Chronicle,* Sep. 12 1840. Daguerre to Minister of Interior: Gernsheim, *Daguerre,* 115.

CHAPTER XIV: LATENT IMAGE

Review of Talbot's photographs: *Lit. Gaz.,* 1217:315–16 1840. Herschel to Talbot: Thomas, 8, 11. Talbot on the calotype: *Lit. Gaz.,* 1256:108 1841; 1258:139–40 1841; *Proceedings of the Royal Soc.,* 4:312–16 1841; British Patents 8842 1841, 9753 1843.

CHAPTER XV: "THE PENCIL OF NATURE"

Brewster to Talbot: Thomas, 34, 36. Talbot on electric flash: *Athenaeum,* 1258:1286–87 1851. Collodion replaces daguerreotype: E. M. Estabrooke, *The Ferrotype,* Cincinnati 1872, 69.

CHAPTER XVI: A UNIVERSAL TECHNIQUE

Talbot to Brande: Unpublished letters, George Eastman House collection. Talbot *v.* Laroche: *Phot. Jour.,* 2:84–95 1854; *Art Jour.,* ns 1:49–54 1855.

INDEX